PHANTOMS
OF THE
ISLES

PHANTOMS
OF THE
ISLES
Further tales from The Haunted Realm

Simon Marsden

BCA
LONDON · NEW YORK · SYDNEY · TORONTO

For Cassie,
whose spirit never waned

Endpapers: SCULPTURE, TODDINGTON MANOR
Half-title page: SATYR FROM THE DEVIL GATES, GLAMIS CASTLE
Title page: DETAIL OF STATUE AT BELVOIR CASTLE

This edition published 1990 by BCA
by arrangement with Webb & Bower (Publishers) Ltd
Reprinted 1991

Designed by Vic Giolitto

Typeset in Great Britain by P&M Typesetting Ltd, Exeter

Text set in 11pt Garamond Original

Printed and bound in Italy by Amilcare Pizzi SpA

CN 9129

CONTENTS

INTRODUCTION

The same ignorance makes me so bold as to deny absolutely the truth of the various ghost stories, and yet with the common, though strange, reservation that while I doubt any one of them, still I have faith in the whole of them taken together.

Dreams of a Spirit-Seer,
Immanuel Kant (1724–1804)

One evening during the summer of 1988 I was having a drink with an old friend of mine in a London club and was in the middle of telling him one of my favourite stories in this book, when we were interrupted by a young man standing next to us at the bar, who asked if we would be interested to hear of an unusual and frightening experience that had befallen him. Apparently he had spent a year working for a mining company in Indonesia after leaving university, and had fallen foul of the native mineworkers by becoming involved in a dispute over their working conditions. He and another member of the management of the mine were cursed by a holy man, or witch doctor, but both of them took no notice of the threat at the time and it wasn't until several months later, after he had returned to his home in England, that he awoke late one night to find a terrifying demon or elemental in his bedroom. He described it as very small with a hideous face, half human, half beast. This terrifying apparition appeared to him several times, once in broad daylight, and he was forced to seek psychiatric help, believing that he was going insane. But of course the experience had been very real to him, and as he had suffered very bad luck around the time of these visitations he can never be sure of the truth of what had really happened to him, although he later discovered that his fellow manager at the mine had been killed in a sailing accident at around the time of the demon's first materialization.

I was naturally surprised and a little frightened by such a strange and disturbing story, told with such clarity and sincerity, but then after fifteen years of research into the supernatural I have frequently found myself the recipient of such tales and, although I try to keep an open mind on all things concerned with the supernatural, occasionally my cynicism will get the better of me, and I will at first dismiss them as being too farfetched to be possibly true, as I did in this particular case. It wasn't until several hours later, as I was leaving the club, that I gazed up into the dark, but clear, night sky, and experienced the same sense of wonder and humility that I remembered as a child, in trying to comprehend that each small star was in reality a blazing sun, and in comparison with which our mother earth is merely a speck of dust. As I lay in bed that night I thought of the young man's story in a different light.

It has never been my personal quest to try and prove that ghosts, or indeed any other form of inexplicable phenomena, exist. I prefer to see myself in the role of an independent folklorist, collecting and recording the experiences and the stories of the individuals concerned with such events, in the hope that by doing this I can help to inspire and restore a little imagination into a world that is daily being dispossessed of any mystery through the relentless and consuming march of science and technology. We should never be frightened of being ridiculed should we question what lies behind the veil of everyday 'reality', or should we try and discover the answers to such superstitions, for, as it is often said, we have to be a little mad to exist in the type of society we have created.

Fear came upon me, and trembling, which made all my bones to shake. Then a spirit passed before my face; the hair of my flesh stood up. It stood still, but I could not discern the form thereof.

The Book of Job 4:14–16

My own experiences of the supernatural have been in the main totally unexpected and less frightening than I might have originally imagined would have been the case, although my experience with witchcraft and 'earth forces' near the Rollright Stones in Oxfordshire, that Colin Wilson attempts to explain in his lucid and intelligent introduction to my previous book, *The Haunted Realm*, definitely affected me greatly at the time. Some more recent experiences appear in this book (**see** Ballintore Castle p28, and Craig Hall p51) but these are somewhat less disturbing. As I was brought up in old, rambling haunted houses similar to many of those featured in this book, I can honestly say that I am not often afraid when I visit these locations, but experience a strange sense of security and am definitely stimulated by them. Perhaps the atmosphere and images rekindle memories of a happy childhood often spent playing alone on such large estates. It is the crowds of aggressive people and the unrelenting noise of city streets that frightens me.

What is it that we think of when the word 'ghost' is mentioned? The spirit of a dead person, their soul, a vestige or trace of something, hence the expression, 'a ghost of a smile'? All these answers seem plausible, but the question of what causes a particular house or landscape to be haunted is not so easy to answer. I favour two particular suppositions; the first is commonly known as the 'Tape Recording' theory and has been the subject of continued discussion in the scientific community during the last decade. It proposes that certain inanimate objects such as stone and wood,

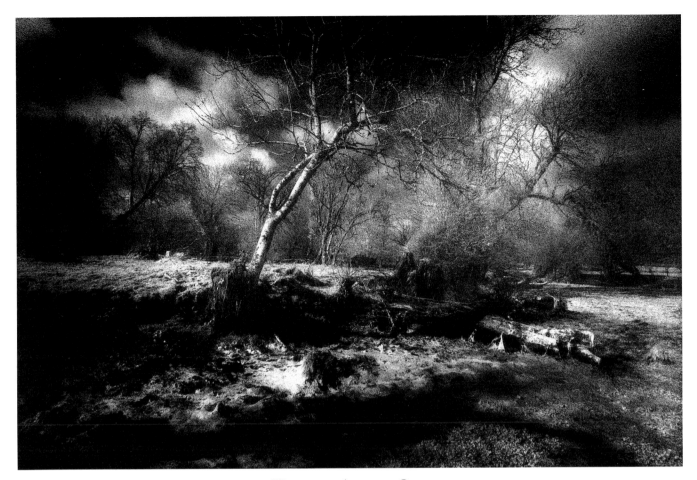

WOODS NEAR ATHCARNE CASTLE

which are frequently found in ancient buildings, give off their own individual electrical fields and that extreme human emotions such as fear, hatred and suffering can be 'imprinted' on these fields and then played back at frequent intervals when they can be picked up by 'sensitive' people who are the most likely to notice them. The large number of wooden beams, taken from ancient sailing ships, that support the ceilings at Plas Teg (p20) may have something to do with the unusual number of suicides and other supernatural phenomena that have occurred there, or the crumbling stones of the cellars at Newark Park (p118) may have trapped some of the sad and lonely feelings of the old people who were sent there to die.

The second, and not dissimilar theory, is that of a so-called 'earth force' or primal energy that emanates from beneath the earth's crust and is conducted along, and emitted by, ley lines, time-worn tracks that connect ancient sites with one another, such as stone circles, dolmens, burial chambers, churches and springs, and it is at the points where these paths of psychic activity cross, that unusual levels of paranormal phenomena have been reported (**see** Leap Castle p112 and 'The Druid's Altar' p26). These primary geodetic lines were said to have been recognized by not only primitive man, but by animals and plants, whose behavioural patterns

around such tracks seem to bear this out. Early man also realized that this primal power was influenced by the sun, moon and stars and conducted his religious and sacrificial ceremonies according to their astronomical significance. Sadly many of these sacred monuments now lie in ruins, or have been destroyed by modern man, but behind this intricate and invisible pattern lies a prehistoric scientific knowledge that we ignore at our peril.

I have found the weight of evidence that surrounds the existence of ghosts and other supernatural occurrences to be overwhelming, and the constant repetition of certain themes throughout the multitude of stories has always impressed me, particularly the theory of 'time-slips' where we are able to see visions of the past as well as the future, the spirits of the dead and the living. Another frequently recurring story tells of a person who dies suddenly and unexpectedly in a foreign land and at the very moment of their death their ghost is seen by a relative or friend, perhaps sitting in their favourite armchair in their own home. An explanation for this type of phenomenon could be that the unfortunate person was not mentally prepared for their sudden death and that their spirit desperately sought the safety of a known environment.

For reasons of compression it is not possible to

[7]

discuss other forms of paranormal forces here, such as poltergeists and witchcraft, but a point that I would like to raise has for me been one of the more fascinating revelations during my exploration in this field, and that is the strength of positive reaction to the subject that I have received when I have been investigating and photographing such reputedly haunted places. I have often felt that, because of my obviously sympathetic views on the subject, my presence acts as a catalyst, releasing a wealth of supernatural experiences that people have often kept hidden away inside themselves for various reasons — fear of ridicule by others, perhaps, or the inability of the human brain to assimilate and interpret such unusual and previously unknown information — and it is fascinating to witness their overwhelming sense of relief at being able to reveal these profound and personal secrets.

> Tis a fearful thing to be no more,
> Or if it be, to wander after death;
> To walk, as spirits do, in brakes all day;
> And when the darkness comes, to glide in paths
> That lead to graves; and, in the silent vault,
> Where lies *your own* pale shroud, to hover o'er it,
> Striving to enter your forbidden corpse.
> *John Dryden (1631–1700)*

From time to time each of us must reflect on our eventual death, however hard we may try to distance ourselves from this certainty. It is impossible for our limited human intelligence to fully comprehend that our once thriving healthy bodies will one day be reduced to no more than a pile of dust from whence we came, and it is therefore true to say that we exist, out of necessity, with our consciousness at the central point of time, not at its termini, and it is this self-preservation that gives us the confidence to live without being in continual dread of death. There are many civilizations throughout the world that uphold a strong belief in reincarnation and the theory that man returns many times and in many different forms, before he eventually achieves an elevated state of harmony with the soul of the universe. But one might equally suggest that the ancient and continuing belief in the return of the spirit, in the form of a ghost, or some other supernatural entity, is a result of the inability of mankind to face up to the finality of his extinction, and that these ghostly visitations are the product of his subconscious fears as he desperately seeks some form of relief from this incomprehensible truth, in the semblance of a possible after-life in spirit form.

What does however seem certain is that as modern man, in the Western world especially, chooses to distance himself ever further from nature, so too he distances himself from the acceptance of his own mortality. His by now fanatical obsession with health and the longevity of life, through the advances of medical science and physical fitness, seems suspect when one questions his motives. Surely he does not wish to live longer merely to be an additional burden on his fellow man in his old age? Is perhaps the truth more likely to be that he exercises and runs more in the hope of putting off the day when he has to face up to his demise, something which he is now so spiritually unprepared for? It is the people of the less advanced nations of the world, through their respect for, and closer proximity to, nature, who are better able to confront and accept this dilemma. Their belief in ghosts manifests itself in a different form, for while they readily accept the existence of such phenomena they are originally more involved with their dead and are therefore less afraid of these spirits as they are of the threat of death themselves. They see themselves more as guardians and protectors of these souls of the dead. For example the Aborigines of Australia are presently attempting to reclaim the bones of their ancestors from various important Western museums and to reunite them with their homelands to prevent their restless spirits ceaselessly wandering abroad.

> The Pagan's myths through marble lips are spoken,
> And ghosts of old beliefs still flit and moan
> Round fane and altar, overgrown and broken,
> O'er tree-grown barrow and grey ring of stone.
> *Unknown*

Since the dawn of time all civilizations have believed in ghosts and the supernatural in some form or other. These are ancient mysteries and to dismiss them is to deny ourselves that arcane knowledge of the past that has ultimately fashioned our lives. Surely we cannot be so foolish as to ignore the beliefs of the myriad of souls who have gone before us, believing that with solely the aid of science and technology we are in total control of our destiny? For wherever we may stand, on no matter which particular landscape of this planet, beneath our feet are the many layers of these previous civilizations, which have left their irrevocable mark, not only on the physical landscape but on our subconscious too.

We are often told that we must not dwell on the past, but that we should rather go forward, progress, but what exactly is meant by progress? Too often it would seem to be an excuse for a scenario of mindless destruction and immediate self-gratification, a pursuit of materialism solely for personal gain. Surely the very word progress should mean improvement not devastation; we must learn from our past before we can ever go forwards. It is interesting to reflect on why modern man feels such a strong urge to change everything around him. Perhaps it is because he is so discontented with himself, so out of touch with his spiritual past and his lack of contact with nature that he is prevented from standing still and taking stock of the nightmare he is creating; a world where his children watch vacuous and grotesque horror videos, whilst consuming synthetic junk food, where families are existing in identical

soulless houses that are not even built to last, like so many other schemes in an uncaring, prodigal society, where money is God. Everywhere we abuse nature, needlessly cutting down trees and polluting rivers that our ancestors believed were inhabited by spirits, even desecrating the graves of the dead by building houses over ancient burial grounds. All this we are told is progress, but we take a terrible risk when we interfere with nature, for as we destroy it, we destroy a part of ourselves.

Yes, there have been remarkable and breathtaking advances in the scientific world, in the fields of space travel and medicine, and especially in everyday communications, but again one questions in this instance what exactly it is that we are so keen for these machines to communicate at such a great speed, and how much of man's original thought and imagination is being destroyed by their use? One can often be under the impression that we are blindly running around in circles, when the simple truth is staring us in the face if we only made the time to stand still and enquire.

When I came to choose the various locations for this book I looked for buildings and landscapes that were in the more remote and isolated areas of the country, where the people have held onto their legends and folklore of the distant past, which is why there are so many in Ireland, a nation that has always respected this ancient knowledge perhaps more than any other country in Western Europe. Since the publication of *The Haunted Realm* in 1986 I have frequently been asked why I don't include more modern buildings, and although the appearance of an ancient Druid in a supermarket or leisure centre is an intriguing image, in the main I find these modern day monstrosities so utterly uninspiring that I see no point in pursuing the idea.

The ghost in man, the ghost that once was man
But cannot wholly free itself from Man,
Are calling to each other thro' a dawn
Stranger than earth has ever seen; the veil
Is rending, and the Voices of the day
Are heard across the Voices of the dark.
Lord Alfred Tennyson (1809–1892)

How then can any of us begin to deny the existence of ghosts when we still do not know how or why we came to be alive in the first place? How arrogant of scientists to pass any kind of judgement on the supernatural when we are today witness to the gradual devastation of our planet by many of their own creations running amok. Behind the multiplicity of theories in the world of science and supposed commonsense, is a single reality, an eternal, infinite truth that lies hidden within us from the moment of our conception in the womb until our eventual death, but this sixth sense, or these spiritual eyes, is gradually blinded to anything that defies the dull logic that governs our lives. This relentless destruction of childhood instinct and innocence, known misleadingly as 'growing up', denies this inherited knowledge and inhibits the true self, and it is this very strong need of the human soul to rediscover this lasting truth that our ancestors so respected, that inspires the more enlightened and sensitive among us to create a fantasy world as a substitute for this false, controlled and unfulfilling existence that society as a whole has created.

It therefore follows that it is not the fantasists of this world who are unrealistic, but the dogmatic and narrow-minded people, who are either unwilling or unable to face this perpetual and omnipresent truth through their own fear and self-interest. If we are to be as one with the universe then we must realize that we exist on a multitude of levels, not just the puny one called 'I', we must rediscover this sense of wonder in the natural world and revel in the 'timelessness' of it all. Hell on earth is surely logic pursued to its futile and tedious conclusion denying all imaginative thought and with no recognition of the powers of the supernatural. I believe that it is the ghosts within us that crave to return and these powers of the supernatural that subconsciously haunt our every living day, and that therefore to deny the existence of ghosts is to reject man's spiritual being, his true self.

NB As many of the houses included in this book are private property and are not open to the public, the author asks that the reader respects their privacy.

BALDOON CASTLE
Wigtownshire, Scotland

Towards the middle of the seventeenth century Janet, the beautiful and eldest daughter of Sir James Dalrymple, an eminent jurist and statesman of Carscreugh Castle in wild and desolate Galloway, was forced to marry a man she did not love. The ensuing tragic events have been immortalized by the romantic novelist Walter Scott in his novel *The Bride of Lammermoor.*

From childhood Janet had lost her heart to a penniless young nobleman, Archibald, the third Lord Rutherford, but her parents, and in particular her antagonistic mother, disapproved of the match and dictated that she must marry Archibald's nephew, David Dunbar, the heir to neighbouring Baldoon Castle. Janet was heartbroken, but her mother's inflexible will could not be softened by the poor girl's pleas, and with her daughter's sad resignation the marriage took place on 24 August 1669.

Although it was a beautiful summer's day and the picturesque church formed an idyllic setting for the wedding ceremony, terrible events were to follow. There are several versions of what happened on the wedding night, but the best known is this: after a great feast and ball at Baldoon, the bride and groom eventually retired to the bridal chamber. Some time later hideous screams and shrieks were heard from within the room. Servants broke down the door and found Dunbar lying across the threshold, dreadfully wounded and streaming with blood. His bride was crouching in a corner, her dress splashed with blood, muttering incoherently to herself, her face contorted by a manic smile.

Somehow Dunbar recovered from his wounds but would never discuss the events of that fateful night. He later married a daughter of the seventh Earl of Eglinton and eventually died from a fall from his horse in 1682. Janet went insane and died within a month of the ghastly tragedy and her true love Archibald, who never married, died a bitter and lonely man in 1685.

The ivy-clad remains of the ancient castle now lie framed between the ornate pillars of the imposing gateway and it is near these gates that the tragic ghost of Janet Dalrymple is said to be seen, keeping a lonely vigil for her lost love, dressed in her tattered white gown, stained with the blood of her unwanted bridegroom.

SEAFORTH HOUSE
County Sligo, Southern Ireland

The Ancient Egyptians' belief in magic attributed supreme powers to their priests or holy men: the mysteries of life and death were laid before them and they could control the secrets of fate and destiny that were hidden from ordinary mortals. Possessing almost boundless powers, they could empower humans to assume diverse forms at will and to project their souls into animals and other creatures; even inanimate figures and pictures could become living beings and carry out their commands. Each person, it was believed, had a 'shadow' or 'double' known as a *kha*, which lived on inside the tomb when their physical body died. Here it was kept alive with fresh offerings of food, drink and

OWEN PHIBBS (1842–1914)

[13]

incense as well as fantastic treasures, but if these gifts were taken away the spirit would wander abroad to reclaim them and to wreak death and destruction on those who had defiled the tomb. Terrifying tales of the 'curse of the Pharaohs' have been told over the centuries, describing the bizarre events and gruesome deaths that have befallen those adventurers who have excavated and robbed the tombs of the ancient kings and queens of Egypt.

It was in the summer of 1989 that I was told about a house in County Sligo, at the north-west tip of Ireland, that had been the focus of similar disturbances at the beginning of this century, and I set out to visit it with an American friend, a fellow photographer, both of us needless to say apprehensive about what we might find there. As we drove towards the house that lies in the shadow of Knocknarea Hill on the shores of Sligo Bay, I told my friend what I had learnt about the

building and its former owners, the Phibbs family, who had lived in this remote district since the eighteenth century. William Phibbs, who had inherited estates throughout the county, was a man of considerable wealth and did not think that his ancestors' house reflected his true standing in society, so he began to build a much larger mansion some two hundred yards away in the classical style of the day.

The work was begun in 1840 and the house contained a large library, a ballroom and a long gallery which was lit by a skylight and was subsequently converted into a museum by his son, Owen Phibbs (1842–1914) an eminent archaeologist, who had travelled widely in the Far East and who filled the room with a collection of Syrian swords and daggers and Egyptian mummies from various excavations he had made. It would appear that almost as soon as these ancient treasures were installed in the house extremely

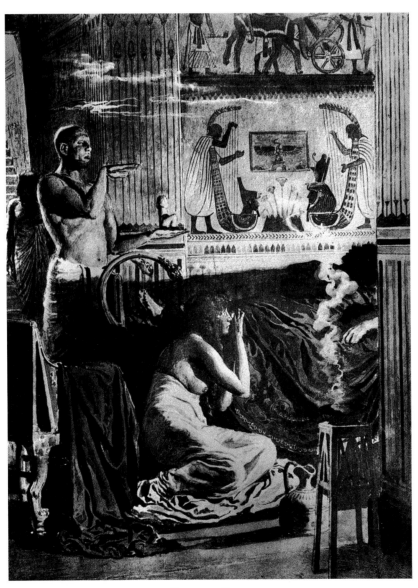

EGYPTIAN FUNERAL
(Hulton–Deutsch Picture Company)

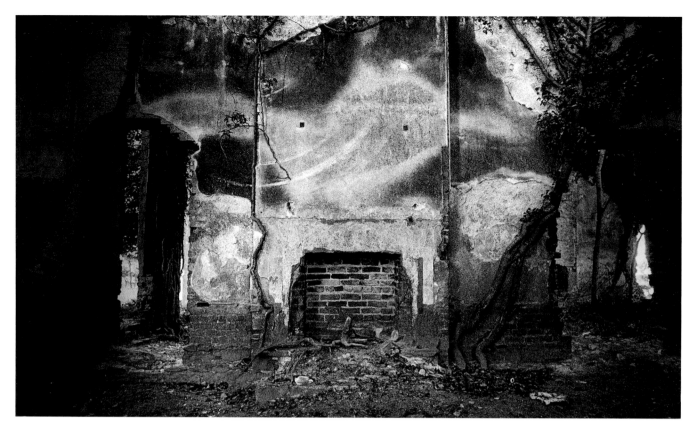

INTERIOR, SEAFORTH HOUSE

unpleasant and malicious poltergeist activities began. It is said that a strange, evil figure would be seen on the stairway at night and that terrible loud crashes were heard throughout the house, with crockery and ornaments found smashed the next morning. On one occasion the whole house was felt to shake. Several of the servants left and an old gardener was terrified by the apparition of a tall, dark shadow disappearing into the sea, followed by maniacal laughter.

The manifestations eventually became so bad that the owners abandoned the house for three weeks to a party of Jesuit priests who said mass every day, but to little avail as the presence is said to have reappeared shortly afterwards. The building was eventually sold, but was abandoned in the 1940s and now stands an empty shell. Since being told these stories I had been shown a newspaper article from a national paper in 1970 which confirmed the hauntings and included an interview with a Father Stephen Brown, one of the Jesuit priests who had taken part in the attempted exorcism. I tried to contact him myself, but it would seem that all the participants are now dead. I was interested to note in the same newspaper article a description of a later member of the Phibbs family, Geoffrey Phibbs (1901–1956), who was a librarian in Wicklow, written by his assistant at the time, the late author Frank O'Connor. 'Geoffrey Phibbs, my boss, was tall and thin and dark, with a lock of black hair that fell over his eyes, a stiff abrupt manner, a curt high-pitched voice and a rather insolent air,' wrote O'Connor. 'He flew into hysterical rages about trifles,' added the author. 'There was something about him that was vaguely Satanic.'

Suddenly we turned a corner and saw the house in the distance, a dark and sombre ruin on a slight hill about five hundred yards from the sea, staring out across the water towards the Ox Mountains. Leaving our car next to the old lodge gate, we began to walk up the overgrown driveway and to photograph the house. Later, when we were inside, my friend suddenly shouted for me to come and join him. He was standing in the middle of what must once have been a large room, with an intense stare on his face. 'Don't you feel something strange in here?' he asked. I stood completely still and slowly looked around me. Certainly, it was oppressive, and the wall above the fireplace had strange patterns on the plasterwork. We both felt very strongly that something terrible had once been in this room and we would be better off leaving the house well alone.

The present owners, who live in the nearby farmhouse, said they kept well away from the old ruin and had not had any unusual experiences there. We walked back to the car, agreeing that this was an occasion when to try to dig any deeper would be unwise. The Phibbs family have long since moved from the area, although one can still see a sign over a solicitor's office in Sligo town that bears the name 'Argue & Phibbs'.

[15]

TINTERN ABBEY
County Wexford, Southern Ireland

Oh save, and I will build to thy glory alone
An altar of gold in an abbey of stone:
An abbey and altar, a church and a shrine,
This heart's grateful offering to mercy divine.
('Tintern de Voto' by John Bower)

Said to have been built about AD 1200 as the result of a vow, Tintern Abbey or 'Tintern de Voto', lies on the west shore of Bannow Bay and is considered to be perhaps the most beautiful monastic settlement in all Ireland. William Mareschal, the Norman Earl of Pembroke, made the promise when he was trapped in a storm at sea while crossing from Wales to Ireland, vowing that if it pleased God to save his life he would build a religious house at the place where he landed. He dedicated the abbey to the Virgin Mary and transported Cistercian monks from the more famous Tintern Abbey in his Welsh homelands to worship here.

So perfect is the site of the now ruined monastery, and so romantic and peaceful are the grounds, that one has to reassure oneself that this is not merely a floating vision, a 'ghost house', but an actual man-made building of a bygone era. Local people told me that the abbey is reputedly haunted by a phantom torchlit procession of monks that is sometimes seen approaching the great Gothic entrance door to the building late at night, accompanied by the mysterious and ghostly sounds of their Latin chants.

The abbey was finally dissolved in 1538 and the lands granted to an Elizabethan soldier, Sir Anthony Colclough, in 1562, who turned the building into a dwelling house where his descendants lived for almost four hundred years. Unlike many of their fellow Anglo-Irish landowners the Colcloughs had an exceptionally good relationship with the local people and several of their number both risked and lost their lives fighting for the Irish cause through the centuries.

When I visited the medieval abbey I was so struck by the beauty of the scene that, in spite of its ghostly reputation, I pitched my tent for the night within the shadow of the monastic building. At around midnight I was suddenly awoken by the terrifying moans and screeches of some unearthly sounding creature. I lay frozen to the spot, unable to move, and prayed that I was dreaming. After what seemed an eternity, when the nightmarish sounds ceased, I finally dared to stick my head slowly out of the tent – there on the roof of the abbey were two young couples roaring with laughter at their unfortunate victim. I didn't go back to sleep again that night, and left as soon as the sun rose over the massive ivy-clad tower of the gaunt ruin.

LOCH RANNOCH
Rannoch Moor, Perthshire, Scotland

Desolate Rannoch Moor is a dangerous wilderness of peat bogs, ancient forests and murky waters surrounded by dark and forbidding mountains. For centuries a haven for outlaws and criminals, with many tales told of their daring exploits, witches too were said to live in caves in the mountains here where they could practise the black arts at will.

On the south-eastern shore of the loch stands the mysterious Schiehallion Hill or the 'hill of the fairies'. Travellers passing by here have told of being followed by a terrifying dog-like shadow that materializes from nowhere. Other strange beings are said to exist throughout the area; water horses and lake monsters beneath the bleak waters and ghosts and elementals that roam the moor.

As the sun began to set I felt both fear and wonder, a sense that I stood on the very shores of the supernatural.

Plas Teg
Clwyd, Wales

Sombre and gaunt, this eerie Jacobean mansion lies only a few hundred yards from the main Wrexham to Mold road in an area rich in prehistoric burial mounds and tales of witchcraft. A giant and forbidding building, it uncannily resembles a vast, dark and ornate mausoleum, and for many years lay derelict, inhabited only by ghosts, until it was recently saved and spectacularly renovated by the remarkable Cornelia Bayley. When I first telephoned her she enthusiastically said that she owned copies of my previous books and that I must come and stay the night as I would be inspired by this house. I was not disappointed. Turning into the driveway I felt intimidated by the powerful aura of the dark manor. I was greeted at the door by a young woman who was caretaking the building in the owner's temporary absence. It was a cold winter's day and I was relieved to be ushered into the atmospheric Great Hall where huge logs glowed in the magnificent open fireplace, providing the perfect setting for the frightening ghost stories I was about to hear.

The house was built in 1610 by Sir John Trevor. The Trevors were a powerful Welsh family, and Sir John held the lucrative position of Surveyor to the Queen's Navy, and many of the great beams that support the mansion's high ceilings were taken from the great wooden ships that were the pride of Britain's naval power at that time. There have been an unusual number of suicides in the house and grounds over the years, and it is another John Trevor, the last of the male line, who haunts the Regency Bedroom where he slowly died in agony from the awful injuries he received after deliberately crashing his horse and carriage following the tragic and mysterious death of his young wife in 1743. Because of its ghostly reputation, the house was shunned by the local people when it was left empty, but there were numerous sightings of strange rectangular lights in this room late at night.

Another grieving phantom is a beautiful daughter of the Trevors who lived about two hundred years ago, and whose lover was killed in a duel by a rival. To avoid the advances of the jealous victor she threw herself and her jewels into a deep well in the garden and her pathetic ghost is said to roam through the house and grounds. She was frequently seen by American servicemen who were billeted at Plas Teg during the last war. It is also said that in the time of Queen Victoria a gardener was sitting on the edge of the well resting

when suddenly he felt sharp, bony fingers clutching his shoulder trying to pull him backwards. Terrified, he jumped up and peered into the murky waters below, but could see nothing. In the nineteenth century there used to be a white stone lodge gate in front of the house where the gatekeeper is said to have hung himself after seeing 'something'. The building was never occupied again and was eventually demolished. Motorists have reported seeing ghostly riders passing through the trees near the mansion late at night.

Unnerved, I was taken on a brief tour of the house. It is almost impossible to imagine how so much restoration work could have been carried out in such a short time. The vast, cold rooms have been filled with beautiful and unusual furniture, wallhangings and mysterious paintings, creating a fantasy world that is hard to describe in words. At one point we entered a room known as the Indian Bedroom, because of its Eastern furnishings, and I was told that it was once used as a local magistrate's court. Felons were sentenced and hung there, disappearing on the end of a rope through a trap door in the floor. Naturally the room is horribly haunted.

Outside the gardens remain an overgrown wilderness, full of architectural curiosities, and I was particularly intrigued by part of a broken frieze of carved heads that resembled a decadent symbolist masterpiece. I was attempting to find the haunted well when a car suddenly drove up and out stepped the fragile figure of Cornelia Bayley, her hair covered in paint from the renovation work she was carrying out at another of her beloved ruins nearby. Over dinner she told me how at first the house had seemed to bring her nothing but bad luck. One of her favourite dogs had inexplicably viciously attacked another for no reason, and she would often hear footsteps and banging coming from the Regency Bedroom. The door of her own bedroom would sometimes shake in the middle of the night as if it were alive. She finally had the house exorcized and since then the disturbances have not been

BROKEN FRIEZE, THE GARDENS, PLAS TEG

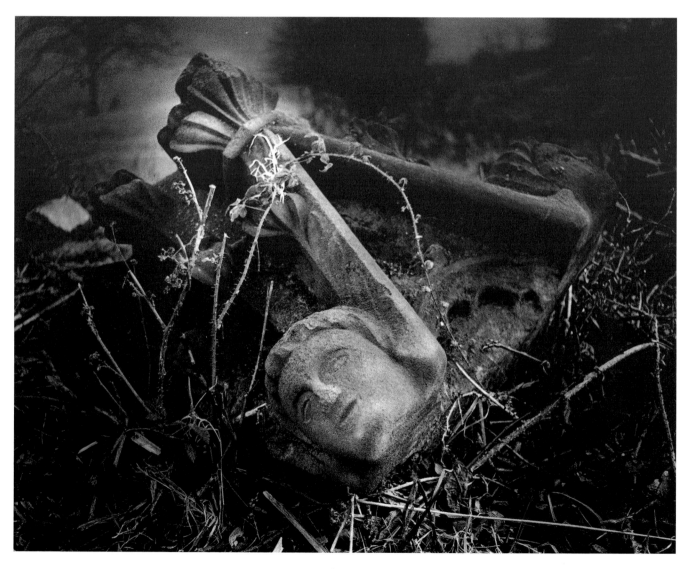

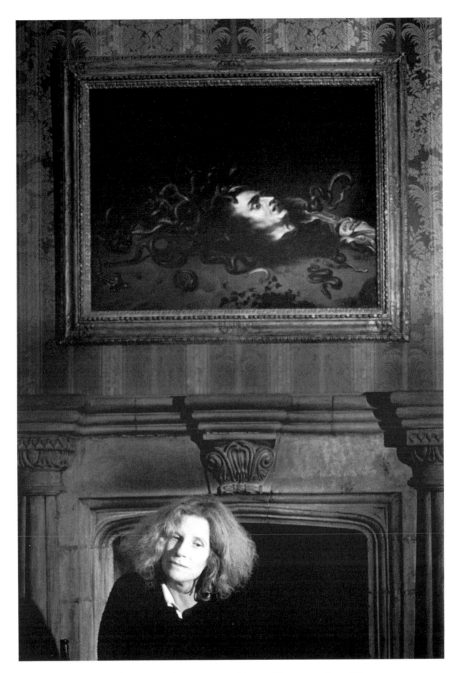

CORNELIA BAYLEY, THE GREAT CHAMBER, PLAS TEG

so bad. She said that she now believed that the spirit of the house had become her lover and she wants to decorate the Great Hall with paint that has been mixed with the blood of all her friends as an offering to the house.

We then retired upstairs to the library where I met the favourite of her menagerie of exotic pets, Grimston, a cockatoo, who sat perched on top of a tall bookcase that he is slowly devouring. Cornelia went on to tell me how she felt possessed by the house and knew she could never leave. 'I will be a ghost here', she said, 'I have no choice.' I took some portraits of her in a room known as the Great Chamber, the hub of the house, that is dominated by a chilling painting of Medusa. I was to sleep in the Amber Bedroom, opposite the Regency Room, and as I lay in trepidation in my four-poster bed, I realized that I must somehow switch off my fervent imagination and pray for deliverance from the unknown. Fortunately I was totally exhausted and somehow managed to sleep undisturbed through the night. After breakfast I thanked my brave and exceptional hostess, who would seem to have risen onto a higher plane than her fellow mortals, existing on a level that is in harmony with the supernatural.

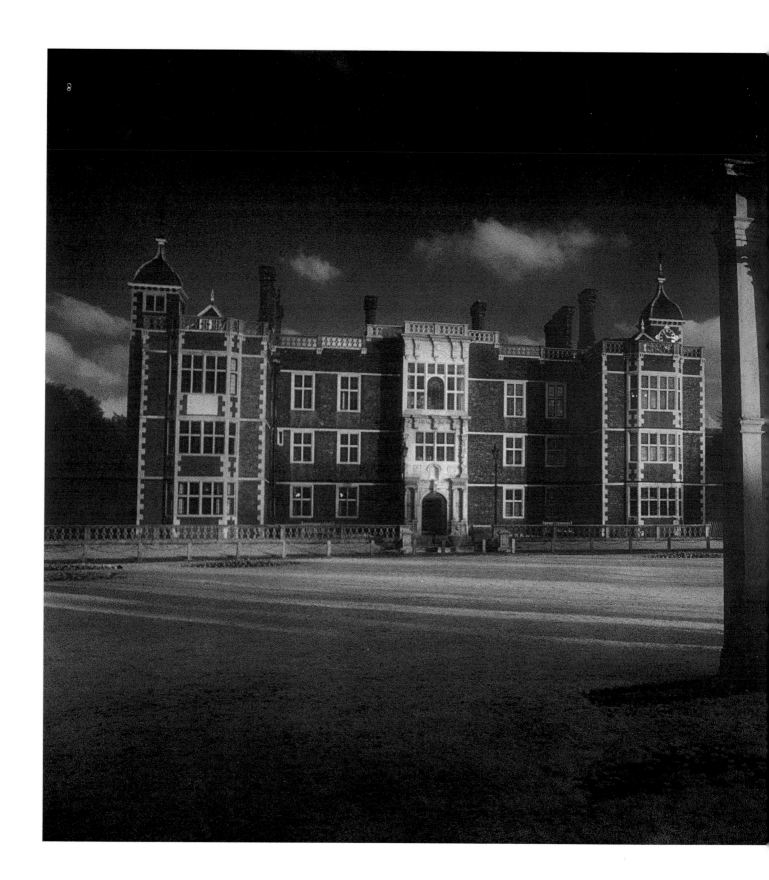

CHARLTON HOUSE
Greenwich, London

Charlton House is one of the finest examples of early Renaissance architecture in London. It was built in the early part of the seventeenth century by Adam Newton, about whom little is known except that he was a royal tutor. In 1680 it was sold to Sir William Langhorne and it is his restless and amorous ghost that is said still to haunt the many corridors and bedrooms of this magnificent mansion. One-time Governor of Madras, Sir William said he bought the house as an 'asylum for his old age', and he lived here until his death in 1715 at the age of eighty-five. During his lifetime he never managed to father an heir and whether it is because of this failing, or his insatiable appetite for the fairer sex, his ghost is believed to be the reason for the unexplained turning of bedroom doorknobs and other supernatural visitations at Charlton to this day.

During World War I the house was turned into a hospital and one of the rooms was ordered to be kept empty because of these ghostly visitations, but due to mounting casualties this plan had to be abandoned and the long-suffering patients were left with yet another 'horror' to contend with besides their wounds. The house was badly damaged by bombs in World War II, and during extensive repair works a gruesome and pathetic discovery was that of the mummified body of a child, hidden in one of the ancient brick chimneys. This might explain the tragic figure of a young servant girl, dressed in Jacobean clothes and carrying a dead baby in her arms, that has frequently been seen in the grounds.

The building is now owned by Greenwich Borough Council and used as both a Day Centre and Public Library. I spoke with two female members of the staff who told me that they frequently felt the presence of Sir William, but did not want to be named for fear of being ridiculed.

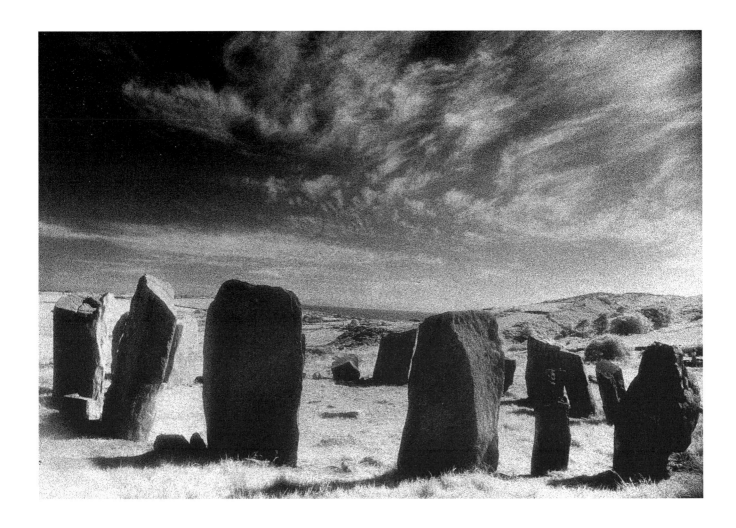

'THE DRUID'S ALTAR'
County Cork, Southern Ireland

Because of its remote position and immunity from the Roman conquest Ireland held onto the Druidic mysteries for far longer than any other nation in Europe. The Irish people have always clung fiercely to the traditions and customs of their forefathers and so it was that the sacred trees and sacrificial stones were not destroyed.

High up on a hillside overlooking the sea, near the village of Glandore, is a spectacular stone circle known locally as 'The Druid's Altar'. An aura of mystery and tales of sinister pagan rites are associated with the ancient stones. During excavations of the site in 1957 the cremated body of a small child was found concealed in a large urn. As far as can be determined this burial dates back to c150 BC.

The Druids — the word means 'the man by the sacred oak tree who knows the truth' — worshipped both the sun and the moon and conducted their ceremonies according to the position of the stars and planets in the heavens. They were known to perform human sacrifices by stabbing their victim in the back and foretelling the future from his or her convulsions. They also believed that the soul was immortal and that it could live on in another's body after death.

It is said that in the last century the daughter of a local farmer, a quiet girl with a sensitive nature and an inquiring mind, developed a fascination for history and all things ancient, and in particular for these old stones. As she grew older she would sometimes sit motionless for hours on end in the middle of the circle, waiting for the sun to set, and her parents became concerned over their daughter's obsessive behaviour. They were greatly

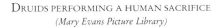

Druids performing a human sacrifice
(Mary Evans Picture Library)

relieved when some years later she married a local schoolteacher, hoping that her interests would change once they started a family.

Indeed, a year later she became pregnant and was as radiant and happy as any expectant mother could be. It seemed that the influence of the stones had waned. Then, about six weeks before the baby was due, her husband awoke in the middle of the night to find her gone. He searched for her everywhere but there was no sign of her. In desperation he ran to her parents' house where her father told the young man to stay with his wife and calm himself while he instinctively set out for the circle. It was a full moon and as he climbed the hill he thought he could see a shape moving through the stones. Praying that it was his daughter he began to run, but when he reached the summit the monument was deserted. He looked around and far into the distance he could make out the silhouette of a figure on the beach slowly walking towards the sea.

The next morning his daughter's dead body was washed up on the nearby shore. What dark and sinister forces had driven the unfortunate young woman to suicide will never be known, but her spirit is still said to haunt the stones, perhaps waiting for a victim to receive her soul?

When I stood within the circle I reflected that we have chosen, whether consciously or subconsciously, to forget or dismiss much of the arcane knowledge of our ancestors, in the pursuit of more immediate scientific gain, thus neglecting the powers of nature and the supernatural. Surely the lesson of this story is that we do so at our peril.

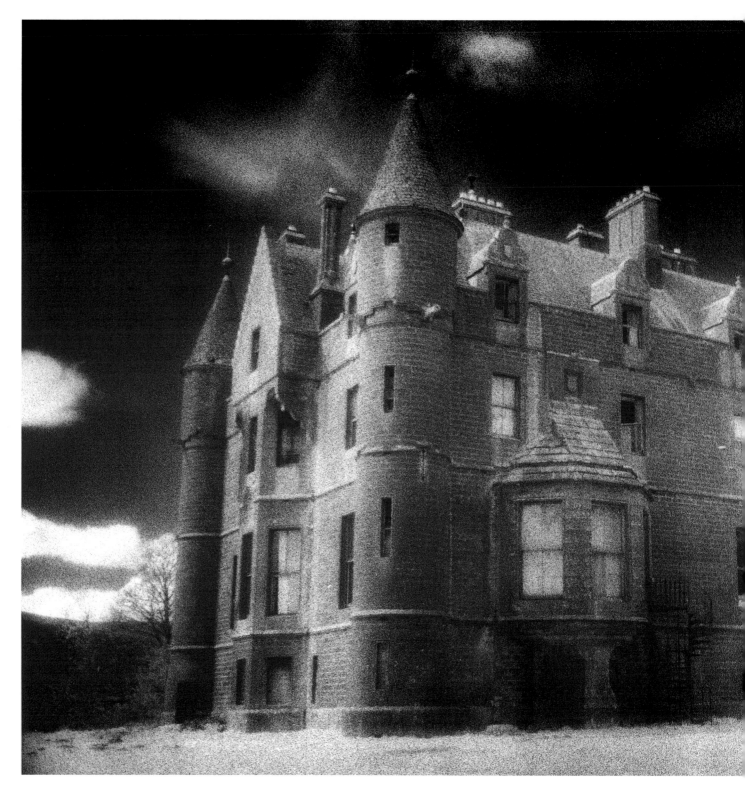

BALLINTORE CASTLE
Angus, Scotland

I came upon this mysterious castle unexpectedly, after getting lost in one of the wilder areas of Scotland. It is dramatically situated high up on a remote grouse moor and I instinctively felt drawn towards it. The eccentricity of the architecture and the uniqueness of the setting gave its decaying towers an unearthly atmosphere of impending doom that made it perfect as an illustration for a book that I was preparing on the life and works of Edgar Allan Poe.

I drove slowly through the deserted lodge gates and up the long driveway. At close quarters the castle looked even more forbidding, as if something quite horrible had happened there once. Then, hidden behind

at which point she laughed nervously and seemed to be about to say something, before turning and walking away.

With a sense of both exhilaration and trepidation I walked around to the front of the house and began to take photographs. Unnervingly the hanging wooden shutters would occasionally slam shut in the wind. At one point, I climbed an old iron spiral staircase to look into one of the windows, half expecting to find some awful spectre staring back at me, but it seemed deserted. By now it was slowly beginning to get dark so, happy with the pictures that I had taken, I returned to my car.

As I went back down the driveway I was thinking about writing to the county library in the hope of learning more about the house when I noticed a small boy, about ten years old, standing near the gates on the opposite side of the road. I smiled at him but he didn't smile back. He appeared to be very sad, with a faraway expression on his face. He was dressed like a gypsy and as I turned the car to drive away I felt that something was wrong. I had driven some thirty yards down the road when I looked in my rear-view mirror: he had gone.

I returned but couldn't find him anywhere; he seemed to have vanished into thin air. At first I felt very confused. His clothes had seemed as if they were from another age — perhaps I had seen a ghost? I sat motionless in the car as the idea slowly sank in. Later I felt a strange relief, although still somewhat disturbed by the expression on the boy's face, and I thought how ironic it would be if I should have encountered a spirit there, rather than the terrifying apparitions that I had imagined haunted the castle.

Later that month I received a letter from the library. They too had very little information on the house except that it had been built by a David Lyon, MP, in 1865 and was described as an elegant castellated mansion, in somewhat bleak surroundings. It had then changed hands several times before the end of the nineteenth century. It seemed that nobody wished to stay there for long. Subsequently it was acquired by a Lady Lyell and even then it was only used in the shooting season, until it was finally abandoned in the 1960s. They did not know who the present owner was.

the building, I saw a small modern house with a young child playing outside. As I parked my car his mother came out and I asked her if she would mind if I took some photographs. She said that she had no objection but advised me not to go inside as it was unsafe. I then asked her what she knew of the castle's history, but she said she was sorry she knew very little about it except that it had been used as a shooting lodge before being abandoned. I said that I thought it looked very haunted

TROLLERS GILL
Yorkshire, England

Marks were impressed on the dead man's
breast, but they seemed not by mortal hand
(Contemporary Ballad)

Trollers Gill is a deep ravine above the village of Appletreewick. In this weird and lonely spot, the rocks rise gaunt and forbidding on either side with yew trees growing from crevices. Legend says that within the caves of the Gill live trolls, impish and malicious creatures who wander abroad at night waylaying and molesting travellers, but who, if caught in the open at dawn, are turned to stone. The King of the Trolls is said to preside over a subterranean palace which is adorned with stalactites and encrusted with jewels.

But the most feared spectre of the Gill and the surrounding countryside is the Barguest, a large dog with long hair and eyes as big as saucers and as bright as fire. He often drags a clanking chain and Trollers Gill is reputed to be one of his favourite haunts. The country folk have long feared him and will make a lengthy detour rather than pass through the Gill at night, for it is said that one glance from his eye means certain death to the beholder.

The following story was recorded in 1881. A young man of the neighbourhood, vain enough to presume that he had mastered the secrets of the occult, resolved to see the Barguest for himself. He set out over the hills on a windy moonlit night and it was not long before the entrance to the Gill rose in front of him. It was too steep for the moonbeams to penetrate and in the darkness, amid the raging water, he thought he heard a loud voice cry: 'Forbear'. He shuddered and, for the first time in his life, felt real fear. But he pressed on, his footsteps echoing like a voice from a haunted tomb, until finally he came to a tall yew tree where he took shelter.

Having regained his composure he drew a circle on the ground, uttered certain charms, bent down and kissed the ground three times, and in a solemn voice called on the spectre hound to appear. A whirlwind sprang up, fire flashed from every cleft in the rocks, lighting up the Gill, and with a wild bark the hound sprang into view, a fiendish glow flashing forth from its eyes …

In the morning a passing shepherd found the young man's body under the yew tree, with strange marks on his breast that corresponded with no human agency. As the calm of the evening settled the villagers silently lowered his coffin to rest in the graveyard, hoping that their own children would in future heed their warnings and stay away from the lair of the Barguest.

I explored the Gill on a warm summer's evening, enjoying the long walk with only the sheep as fleeting company. As I later raised my camera to photograph the steep crags of the ravine, I suddenly felt I was very much alone.

THE INCANTATION OF EVIL SPIRITS
(Mary Evans Picture Library)

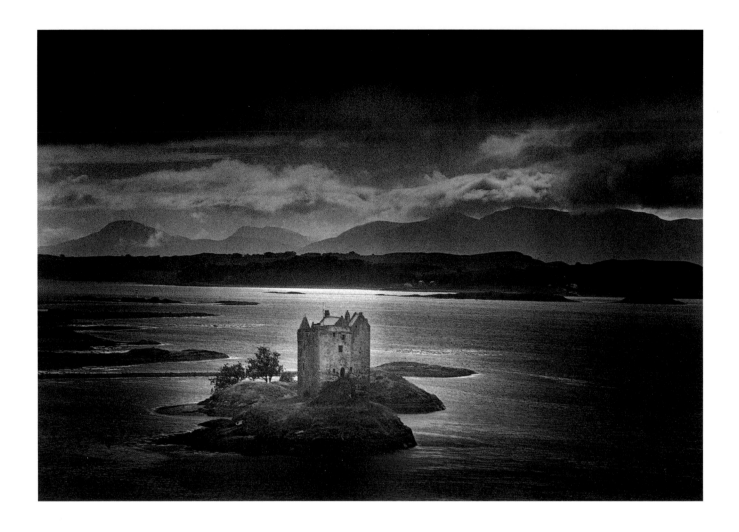

CASTLE STALKER
Argyllshire, Scotland

Dramatically situated on a small island in Loch Linnhe, this castle was for a long time the seat of the powerful Highland clan the Stewarts of Appin, staunch supporters of the Jacobite risings in 1715 and 1745. The massive keep was built in the fifteenth century by Duncan Stewart, who was later appointed Chamberlain of the Isles by James IV, and the king was said to have hunted frequently from the castle.

An old man in nearby Port Appin told me stories of the warlike clan and their exploits and how, after the ninth chief, Dugald, was forced to sell the estate in 1765, a dungeon or 'pit prison' was discovered beneath the floor at the foot of the main stairway, the only access being through a trapdoor. He said that a large quantity of human bones was discovered there and then transported in sacks to the mainland for Christian burial. He also told me that when he was a boy he had heard of an ancient legend, of a strange 'orb of light' seen hovering over the castle when the death of a Stewart chieftain was imminent. When I asked him whether the castle was haunted he said that he could not say for certain, but nothing would induce him to spend a night there.

KILLUA CASTLE
County Westmeath, Southern Ireland

One of the most romantic ruins in Ireland, Killua Castle was the seat of the Chapman family who originated from Leicestershire in England and obtained large tracts of land in Ireland during the sixteenth century through the patronage of their celebrated cousin Sir Walter Raleigh. The present house was built in 1780 and was converted to the fashionable Gothic style sometime around 1830. The vast demesne, with its many lakes and follies, includes an obelisk that commemorates the planting of the first potato in Ireland by Raleigh. The last of their line, Thomas Chapman (1848–1919), had married a Rochford who bore him four daughters, but the marriage deteriorated and he spent long periods of time in England, where he met and fell in love with a Sarah Dunner and changed his name to Thomas Lawrence. They had five sons, one of whom was to become a legend in his own lifetime; T E Lawrence, or Lawrence of Arabia, the controversial white leader of the Arabs during World War I. An enigmatic and mystical figure, Lawrence never lived at Killua but did visit the castle and was inspired by its splendour. His ghost is said to haunt his home in England, Clouds Hill in Dorset, but whether he is the white phantom sometimes reported here near the ruins is not known.

One spirit that *is* thought to haunt Killua is that of Jacky Dalton, the bizarre land steward to Sir Benjamin Chapman in the late eighteenth century. This extraordinary man was said to have had an unusually close relationship with his employer and would often sit at the foot of Sir Benjamin's dinner table where he would play the bagpipes for his guests. He was described as a very small, cunning man with a 'weasel eye' who wore a particularly strange yellow wig. This rogue relieved Sir Benjamin of considerable sums of money, but after his master's death turned to drink, finally committing suicide by jumping into a lake. His eccentric spirit has terrified several nocturnal visitors to the castle.

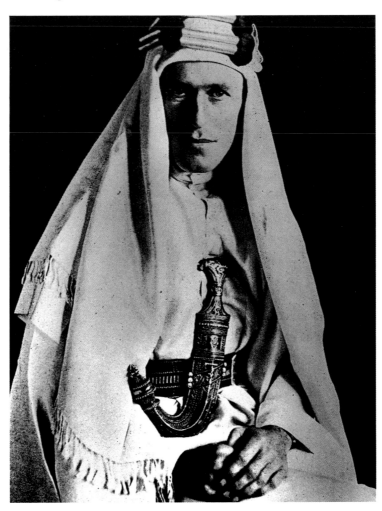

T E LAWRENCE, 'LAWRENCE OF ARABIA' (1888–1935)
(Mary Evans Picture Library)

[33]

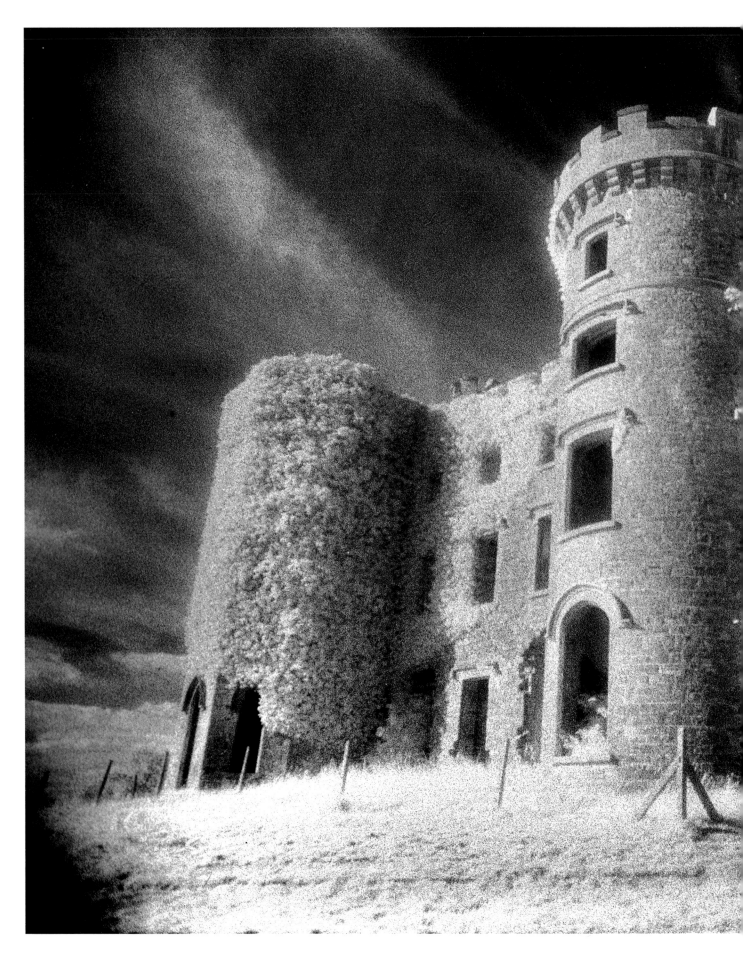

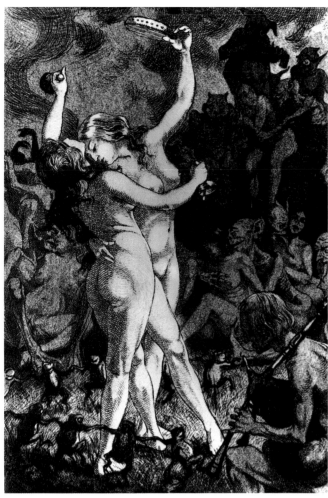

WITCHES' ORGY
(Mary Evans Picture Library)

OLD ABBEY
County Limerick, Southern Ireland

The once extensive grounds of St Katherine's Nunnery near Shanagolden are now almost entirely surrounded and enveloped by thick undergrowth and twisted trees, as if they were hidden in an ancient forest. It was a hot and oppressive summer's evening when I fought my way through to the ghostly ruins, whose aura of solitude and mystery made me think I was perhaps the first person to have done so for a hundred years or more.

According to the historian John Wardell, writing in the *Irish Archaeological Journal* in 1904, little is known of the history of the Augustinian nunnery, which is surprising as it was of considerable size and importance. No records exist of its foundation, but it is first mentioned in the Inquisition of 1298. He adds that there are many legends connected with the nunnery, most of these involving the supernatural.

Tradition says that, following one of the numerous battles waged between the Geraldines and the Butlers, an Earl of Desmond and his Countess were escaping from their besieged castle when his wife was shot by an arrow and mortally wounded. Believing her to be dead the earl fled to the deserted nunnery where he hastily buried her under the altar in the main chapel. Then, heartbroken, he travelled on to Askeaton. But it is said

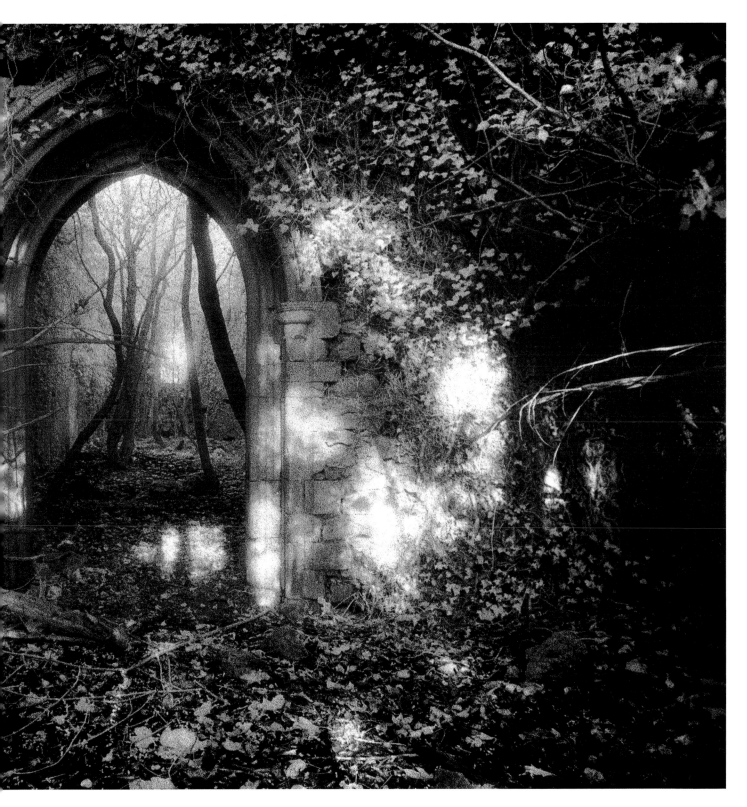

that the ill-fated lady was buried alive and that her ghost still haunts the scene of her horrible death.

The nunnery was said to have been dissolved by the Pope in 1640 because of an evil abbess, whose sexual exploits and practices in the 'black arts' had outraged and terrified the local people. After the departure of the other nuns she remained in the deserted convent, attaining such a great age that her face was said to have become 'quite black'. She hid away in the sacristy where she died alone, and this room later became known as the 'Black Hag's Cell'.

Over the years several skeletons have been unearthed in the grounds of the nunnery. The eerie silence and the memory of these legends was beginning to unsettle me and so I began to retrace my steps back through this haunted and forgotten wilderness.

HARLAXTON MANOR
Lincolnshire, England

The life's work and ambition of one man, this mansion, an Elizabethan baroque fantasy, appears at the end of a long avenue like some incredible vision from an opium-inspired dream. The benefactor and architect was wealthy bachelor Gregory Gregory (1786–1854), who set out to build and furnish a personal palace of unrivalled splendour, but sadly died only three years after its completion. He travelled the world in search of objects and curios to embellish the house, and the lavish interiors are only equalled by their sensational gates, turrets and balustrades on the exterior, guarded by great stone lions, that add to the singular impression of wealth and power. On his death the house passed to his cousin Pearson-Gregory, an eccentric man who lived in the past and who forbade the installation of electricity and telephones so that the vast building was lit only by oil lamps and candlelight. The house became run down after his death and was only saved from demolition by a Mrs Violet Van der Elst in 1938, whose extraordinary life and achievements more than matched this unique house, and it was during her time here that various supernatural occurrences began to be reported.

Described as a reformer, composer, mystic and businesswoman she was the daughter of a Middlesex coal-porter and a Quaker washerwoman. Her fortune had been made through her manufacture of the first brushless shaving cream and she proceeded to spend much of this on refurbishing the manor, which she

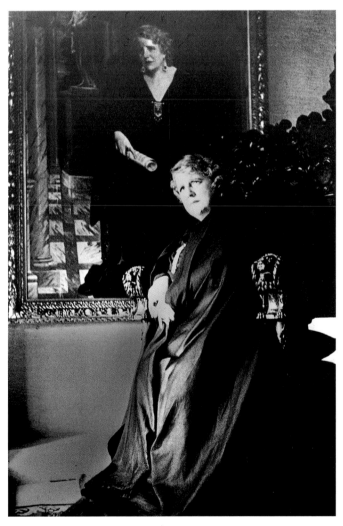

MRS VAN DER ELST SITTING IN THE GREAT CHAIR
OF THE DOGES OF VENICE
(Hulton-Deutsch Picture Company)

LEFT: URN, THE ENTRANCE HALL, HARLAXTON MANOR

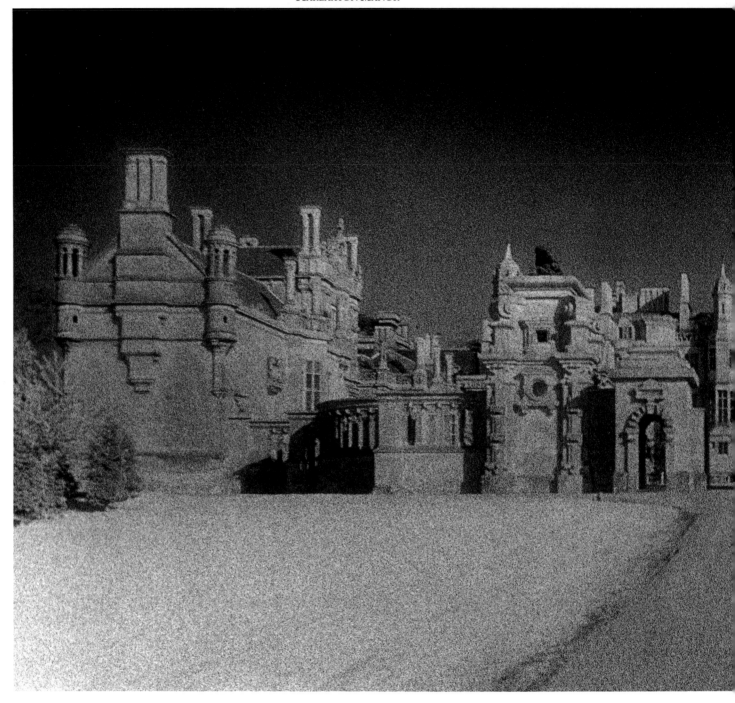

renamed Grantham Castle. She was vehemently opposed to capital punishment and was arrested no less than six times during her successful campaign of protest. During her lifetime she wrote and composed many symphonies, concertos and nocturnes, and compiled a library of over three thousand books on the occult. It was in this library that she held seances, chiefly to try to contact her second husband, the Belgian artist John Van der Elst, who died in 1934. She placed his ashes in a casket and put them inside an urn which stands in the main entrance hall. Later, when she had dissipated her fortune and been forced to sell the house, the casket was accidentally sold, but has since been returned. Today the manor is the residence of an American University.

Approaching the manor I felt a strange sense of unease. I had never seen anything as fantastic as this stupendous building before and it was overwhelming. I felt as if I had mistakenly ventured onto a vast stage where nothing seemed real or tangible. The curator, Frances Watkins, enthusiastically showed me through the impressive interior of the house. She said that many students and teachers over the years had reported seeing ghosts in the house and several staff had left unexpectedly, saying that they felt uneasy living here, but as to the identities of the various apparitions nobody was certain. Mrs Watkins also showed me a

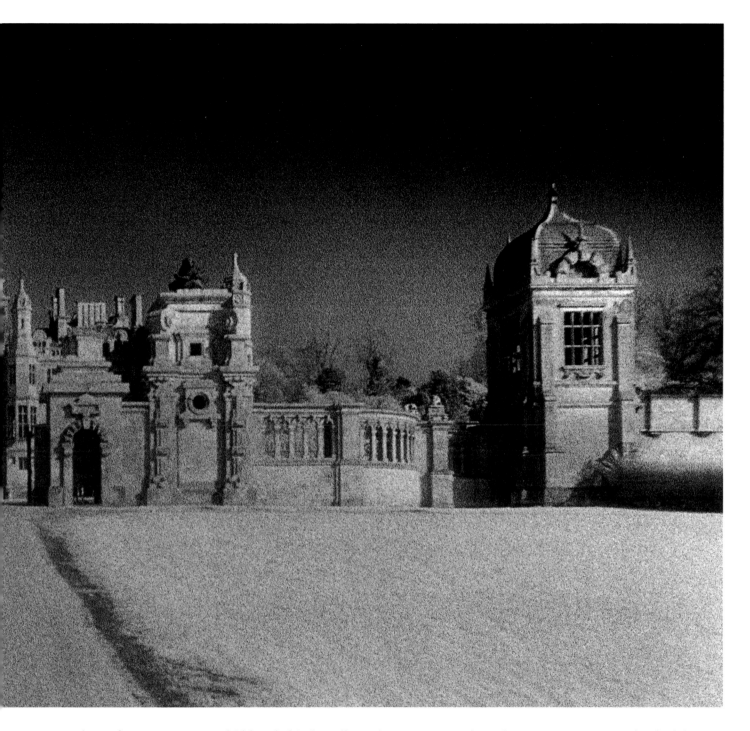

number of secret passages hidden behind walls and fireplaces, adding that in Mrs Van der Elst's time all the carpets in the house were black and the rooms and corridors were filled with strange and macabre statues. Even today, despite the obvious college atmosphere, I sensed an awesome, mystical power as I climbed the great carved staircase. The house seemed alive with the spirits of the past and the library was a particularly powerful source of energy. It is indeed hard to believe that the love, dedication and eccentricities of the manor's former owners have left no trace on this magnificent building.

Some two months after I visited Harlaxton I was put in touch with a young woman who had been a resident teacher there over a two year period and who had had several unnerving experiences. She told me how she had seen the hazy outline of a tall man standing in the doorway of the library for some twenty minutes while she and some of her students were watching a video. She had felt a heavy weight on her and was transfixed by this image until it suddenly disappeared. Another frequently sighted apparition was of a man in a black cloak who would approach the end of one's bed at night. She said that he had been seen by many independent witnesses.

GIGHT CASTLE
Aberdeenshire, Scotland

And Ruin is fixed on my tower and my wall,
Too hoary to fade, and too massy to fall;
It tells not of Time's or the tempest's decay,
But the wreck of the line that have held it in sway.
(Byron 1788–1824)

The desolate and windswept demesne of ruined Gight Castle exists today as a fitting memorial to the wild and unruly Clan Gordon. Known as the 'Gey' Gordons, the word 'Gey' (not 'Gay') meaning 'reckless', the turbulent history of this particular branch of the clan is now part of Scottish folklore. The only child of Catherine Gordon, who was the thirteenth and last Laird of Gight and whose husband 'Mad Jack' Byron gambled their fortune away, was the famous poet Lord George Gordon Byron, whose notorious behaviour so shocked the nation.

The castle was built by the second Laird in 1560 and from then onwards their clan's history is one of

GEORGE GORDON, LORD HADDO (1764–1791)
(National Trust for Scotland)

murder, imprisonment, execution, suicide and sudden death, with some of these unfortunate spirits returning to haunt the estate. Among them is Byron's mother whose pathetic, pleading ghost has been seen near the castle. It is said that long before her husband tried to sell the castle to pay off his debts Thomas the Rhymer, the itinerant seer, had prophesied:

when the heron leaves the tree
The laird o' Gight shall landless be

[42]

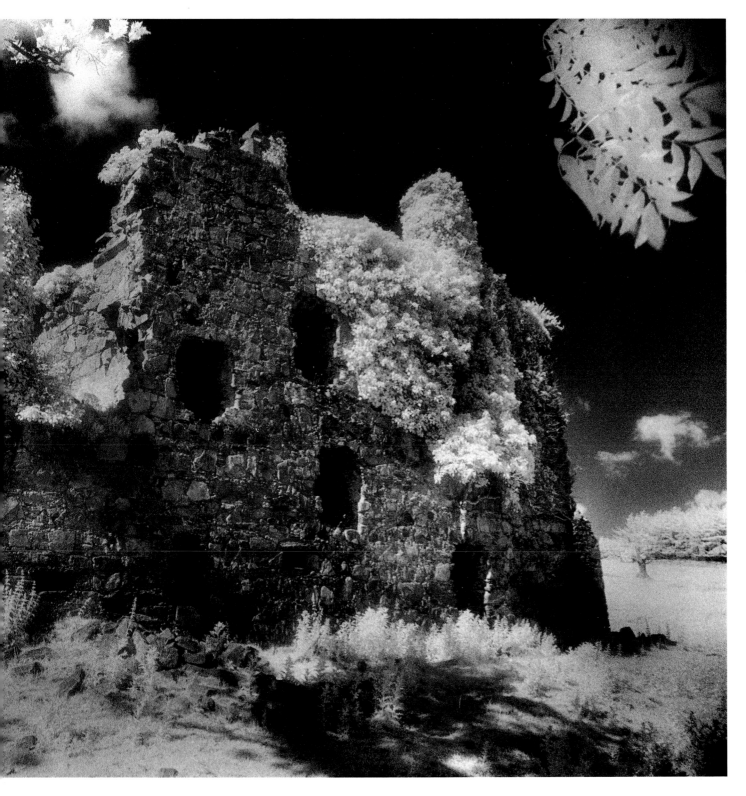

The proposed sale fell through in 1786 but the herons, who had always nested below the castle on the River Ythan, flew instead to Haddo, the home of another branch of the clan. The following year the third Earl of Haddo was able to buy the castle at a knock down price for his son Lord Haddo, but tragically this son was killed in a riding accident in the castle grounds in 1791 when only twenty-seven years old. The castle was then abandoned, but the handsome young man's ghost can still be seen riding through the avenue of ancient trees in front of the ruin.

Another legend tells of a dark, bottomless whirlpool near the castle known as 'Hagberry Pot'. One of the last lairds of the castle was said to have practised witchcraft and to have hidden his treasure in the pool when under seige. Later, when he sent two divers down to retrieve it, one disappeared and the other became insane, saying that he had seen the devil himself, surrounded by serpents.

BODMIN MOOR
Cornwall, England

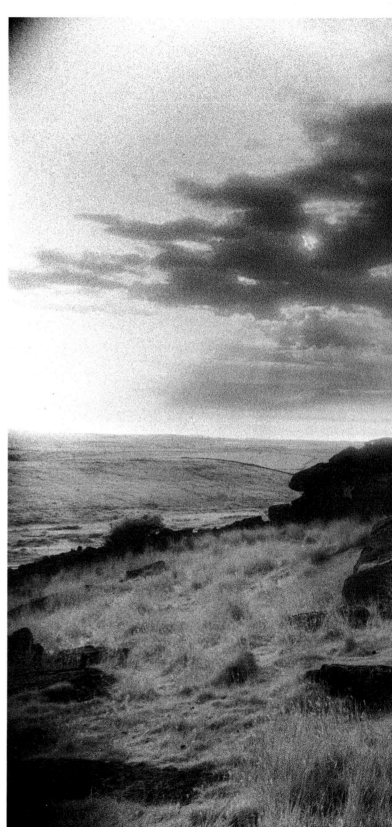

This is the most haunted landscape I know, a dark, wild and dangerous place that is saturated with ancient history and myth. The area has a strange drawing power, a cruel spell that lures one unsuspectingly into its web of eerie landmarks; stone circles, celtic crosses, disused mines, deep and mysterious pools and the remains of prehistoric villages all lie scattered across the moor, then, as night falls, wild animals wander the unseen horizons and the ghosts of primitive man are said to rise from their graves.

One summer's evening I found myself driving through this wilderness near the small village of Minions. I had been here once before, to photograph an ancient burial chamber associated with the spectre of a Druid priest, for a previous book, *The Haunted Realm,* and remembered the group of ghostly, deserted mine buildings that stood out against the skyline. They reminded me of the strange beliefs and superstitions of the miners themselves, and the ghostly knocking sounds that are still said to be heard from the depths of these

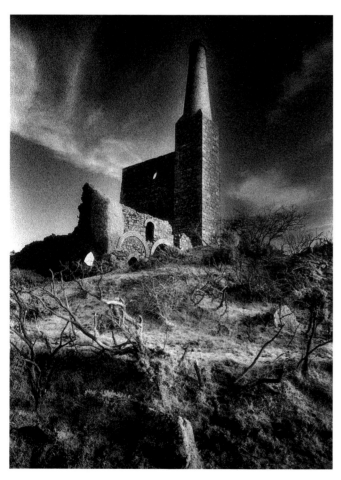

DISUSED MINE WORKING, BODMIN MOOR

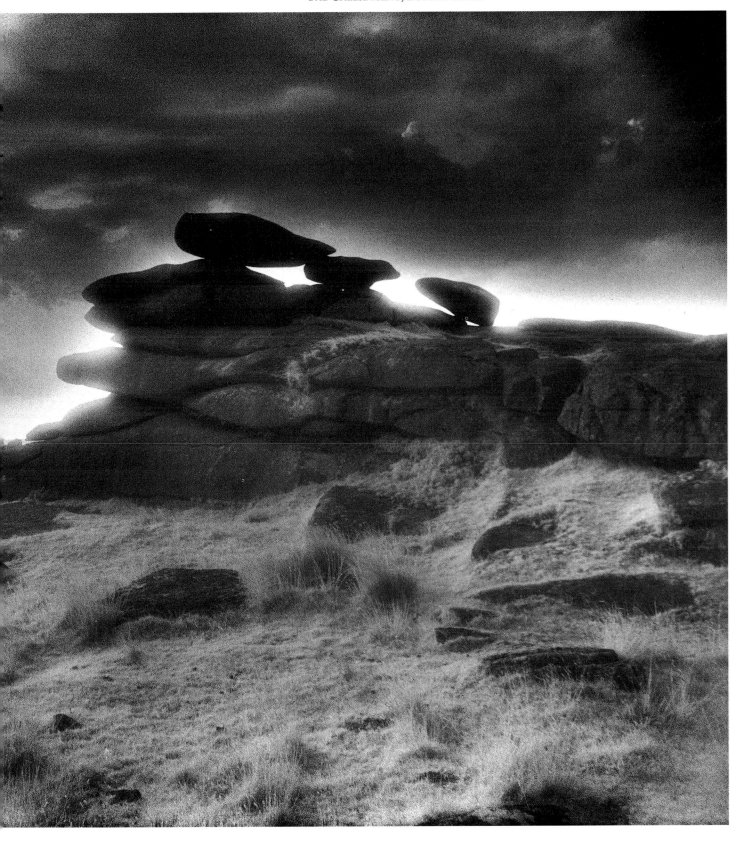

village on the moor, or heard of its eccentric vicar who was said to have practised witchcraft and still haunts the old rectory grounds. I said that I had not, but would be sure to visit there tomorrow, and with that bade them goodnight.

In the morning I drove to this remote village and headed for the ancient little church. There I found an old man scything the overgrown graveyard who had known the vicar, the Reverend Densham, who was a complete stranger to the area, and had arrived at the parish in 1931. His past was a mystery, although there were rumours that he had served as a missionary in India, and during the first two years of his incumbency his unconventional ways so outraged the parish council that they petitioned the Bishop of Truro to remove him, but were unsuccessful and so the local people deserted the church. In reply the vicar put up a twelve foot barbed wire fence around the rectory grounds and over the following twenty years became a virtual recluse. He painted the inside of the rectory in bright colours with large red crosses in every room, hence the accusations of witchcraft, and every Sunday he still said mass in an empty church, making the same entry in the service book almost every week, 'No fog, no wind, no rain, no congregation'. In the depths of his loneliness and

CELTIC CROSS, BODMIN MOOR

THE REVEREND FREDERICK WILLIAM DENSHAM,
VICAR OF WARLEGGAN (1931–53)

now long disused pits. In the far distance I could see the strange leaning rock formation known as the Cheesewring, which is thought by many to be a source of psychic power. It was now almost dark and so I decided to find a place to stay for the night.

Only a few miles further onto the moor I came to a pub that advertised rooms for the night. After dinner I went into the old bar for a drink. It was empty apart from an old man sitting talking to a large, smiling woman who was serving him. The pub was almost an identical replica of one that I had seen in a recent film version of Conan Doyle's *The Hound of the Baskervilles*; it was dark, with a stone floor, and the walls were covered with unusual ornaments and old hunting prints. We began discussing the moor and my interest in the supernatural and the two locals told me several extraordinary and frightening stories of what, in their own words, 'lay out there in the wilderness'. Tales of ghostly carriages with skeletal drivers, of people who had literally vanished in a strange mist that descends without warning, and of certain remote spots where one experiences horrific feelings of 'timeless melancholy' and 'evil foreboding'. Finally the old man asked me if I had ever been to Warleggan, said to be the loneliest

DOZMARY POOL, BODMIN MOOR

eccentricity he made life size cardboard replicas of former rectors to listen to his sermons which were usually on the theme, 'God is love'. Even sadder was the children's playground that he created in the grounds of the rectory, but no children ever came. Then in 1953 he died as he had lived, alone, on the stairs, trying to reach a bellrope to summon help. His body was not discovered for two days and was taken away in a dog cart. His sad, dishevelled ghost is said to haunt the overgrown pathway between the church and the rectory. The old man added that he was in fact a kind,

intelligent human being, who would walk miles to visit the sick or dying. He had merely been the victim of circumstance.

Moved by this bizarre story I left the village, but had only gone a few miles when I saw a sign to Dozmary Pool, where legend says that King Arthur's sword Excalibur was thrown to the Lady of the Lake. I walked down to the shore of the Pool and gazed out across the calm, dark waters at the weird lunar landscape beyond, sensing that I was at the very edge of the unknown.

ATHCARNE CASTLE
County Meath, Southern Ireland

The crucial defeat of a Catholic army under James II by the Protestant forces of William of Orange at the Battle of the Boyne in 1690 has shaped the course of Irish history for centuries. The sombre ruin of Athcarne Castle lies only six miles from the site of this momentous battle, an event which has left a tragic aura on the surrounding countryside. Legend says that before the battle the unfortunate James II stayed overnight at the castle and to this day his ashen-faced, disdainful apparition is said to haunt the castle ruins.

There are other manifestations too, including the ghostly tableau of a dead soldier hanging from an oak tree in the grounds. More frightening still is the spectre of the demented, staring face of a young girl, whose hands are dripping with blood and who was last seen by a farm labourer some three years ago. Whether the blood is her own or her lover's we shall never know.

The castle was originally built by William Bathe in the sixteenth century on lands that were granted to his family after the Norman invasion of Ireland in the twelfth century. Three members of this family were Lord Chief Justices of Ireland in later centuries.

I felt a sepulchral and eerie silence here and it was not hard to imagine that many of the castle's secrets must have been stored in the massive, fallen stones that now surround the crumbling castle walls: a scene that so accurately portrays the demise of the Jacobite cause in Ireland.

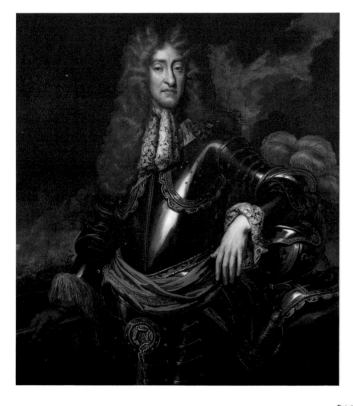

JAMES II (1633–1701)
(National Portrait Gallery, London)

[48]

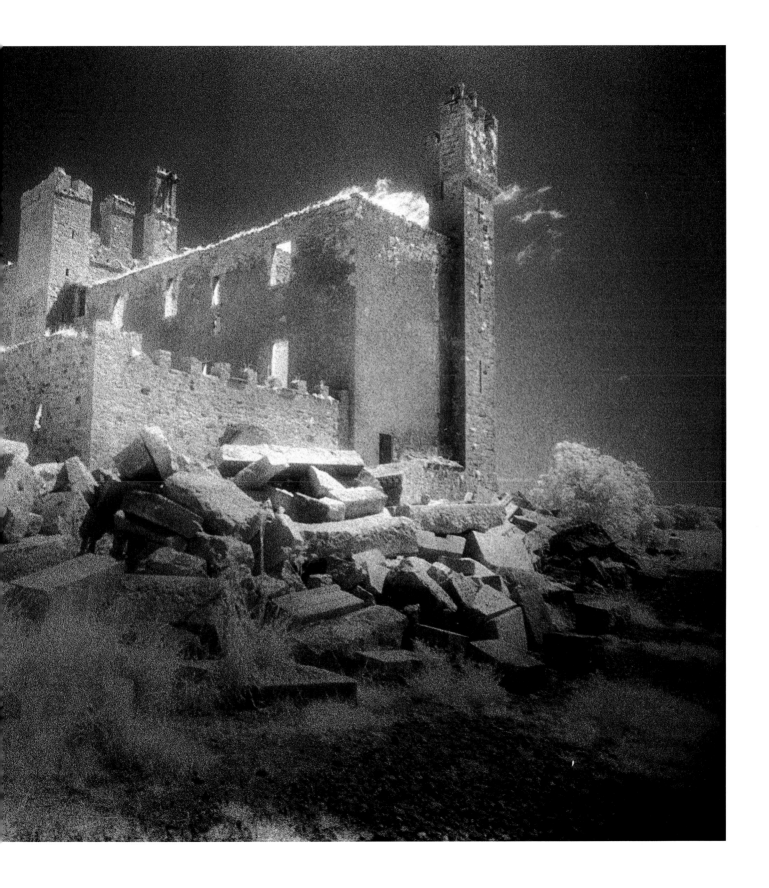

CADAVERS,
ST PETER'S CHURCHYARD
Drogheda, County Meath, Southern Ireland

These very tall, macabre and terrifying cadaver stones are cemented into the high wall of the cemetery behind St Peter's Church in Drogheda. They are the vast coffin lids taken from the ancient tombs of Sir Edward Golding of Peristown Laundy, and his unfortunate wife, Elizabeth Fleming, the daughter of the then Baron of Slane. Both were said to have drowned in a mysterious boating accident on the nearby River Boyne in the sixteenth century, along with Sir Edward's mistress, whose death or place of burial is not recorded. Their skeletal effigies stand bolt upright with their backs to a narrow street of modern houses, the unearthly picture made even more surreal by the intrusion of television aerials and telephone wires. The present vicar of St Peter's, whose beautiful old rectory lies close to the churchyard, said that he knew of the drowning legend and that, whether or not it was true, the monuments were certainly held in what could only be described as 'holy horror' by the local people.

From the moment of my arrival rain had been pouring from a dark sky but suddenly the sun began to shine through to light up the damp, though by now shining, monuments with an unearthly glow. Then as I began to take photographs I became aware of an old lady watching me. I waited awhile, but as she didn't go away, I asked her what she knew about the cadavers. She told me the drowning story again, adding that over the years people had claimed that the figures sometimes 'came alive' to haunt passers-by, but she didn't see how this could be true.

I continued to photograph the figures and she followed close behind me. Then I heard her say: 'My dog will never go into the churchyard, he is afraid of something,' and a few minutes later she added, 'Since my husband died I never walk down the alleyway behind the wall as I once sensed a long shadow overtaking me.'

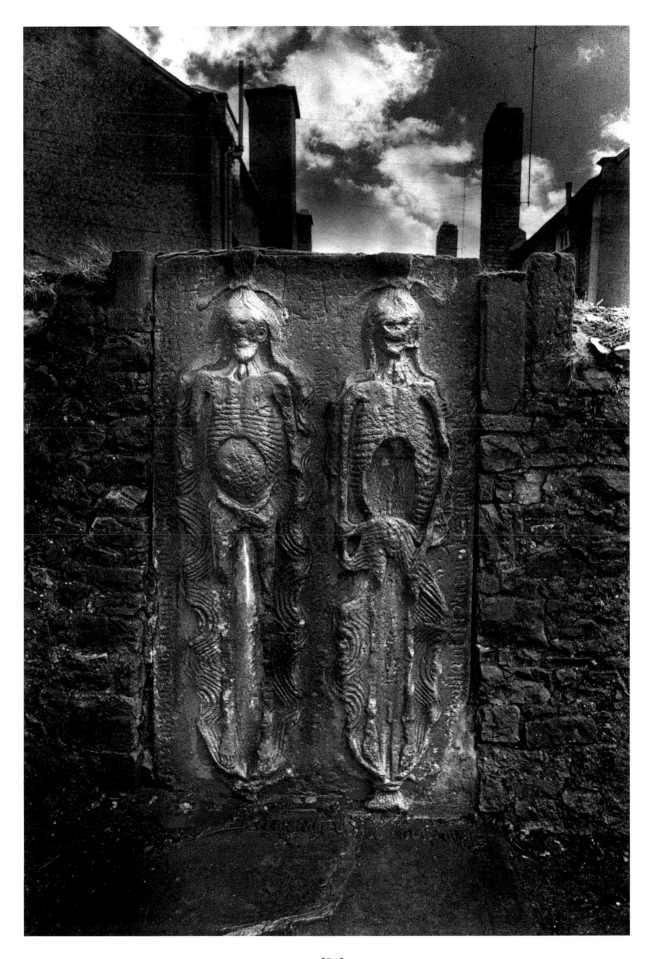

CRAIG HALL
Perthshire, Scotland

Of all the haunted houses I have visited on my travels through the British Isles, none can compare with the setting of Craig Hall in Perthshire, the ancestral home of the Rattray family. The house is precariously and spectacularly perched on the edge of a steep cliff overlooking the River Ericht and, when viewed from the road at night, can inspire nightmares in even the most hardened and cynical unbeliever in the supernatural.

The long, potholed driveway up to the house twists and turns for what seems an eternity and I felt that I had encountered almost every species of Scottish wildlife on the journey. Then, after one particularly sharp bend, the hall appeared; a mass of baronial towers and turrets, its twisted iron balconies suspended below dark, staring windows, the whole scene partially immersed in a cobweb of skeletal trees. It was at the end of a beautiful summer's day, but no sooner had I set eyes on the mysterious building, which seemed literally to crawl with shadows, than I sensed that I had stepped through the invisible portals of some demi-world.

I rang the front door bell but there was no reply, and so, after a long time, I tried the door handle and, finding it open, decided to enter. The hallway and passageways were dark and lined with faded tapestries, armour and striking family portraits. The Rattrays, a family of Catholic Royalists, have lived at the hall since the sixteenth century and have a history as colourful and violent as any of the Highland clans, suffering their fair share of tragedy. The name Rattray dates from prehistoric times being derived from the old Gaelic word *rath,* meaning an ancient earthen fortification.

Eventually I managed to track down the present owner, Lachie, who was hidden away in a back room plucking some grouse for our dinner. He lives at the hall with his wife Nicky and their young son, who were away at the time. He is an intelligent and sensitive man and we soon began to discuss the subject of ghosts over a drink. He described to me how as children he and his brothers and sisters had been terrified at the hall by the many strange noises, footsteps and knockings that they had heard in the dead of night. They were too frightened to play in the eerie, dark North Passage, where they always felt that they were being 'watched' by something or someone. This passage leads to the

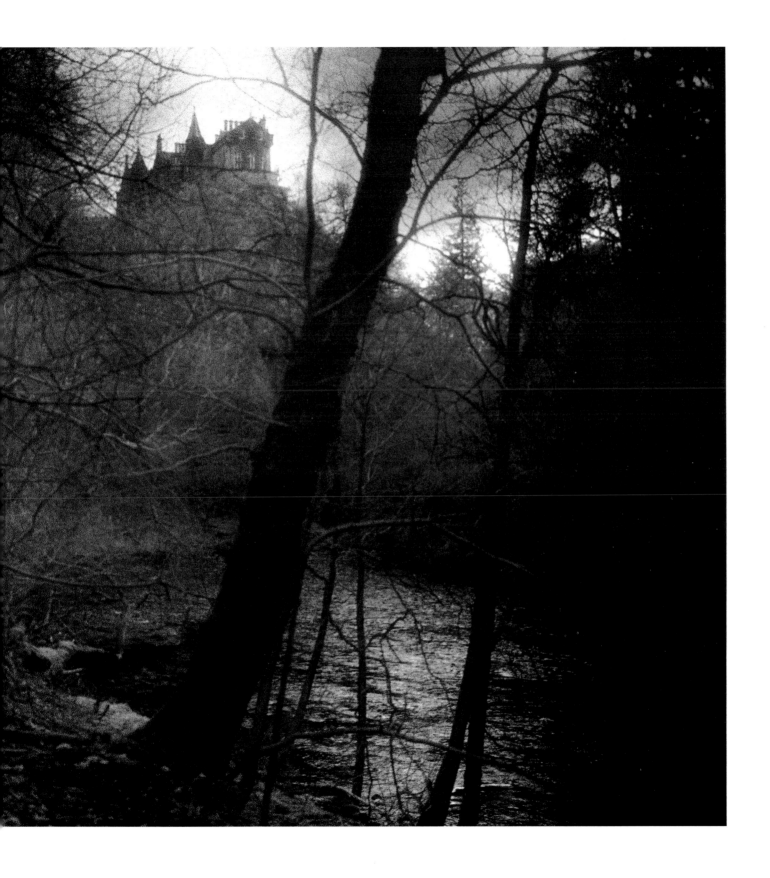

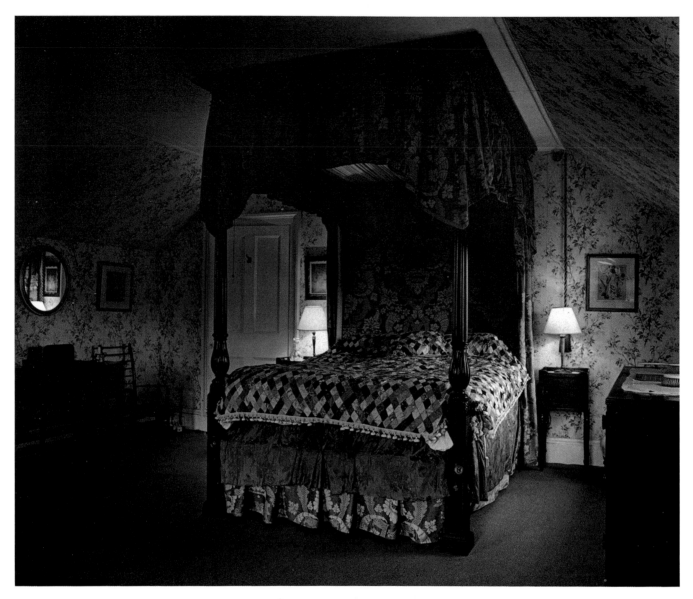

THE HAUNTED BEDROOM, CRAIG HALL

North Room, which is in the oldest part of the house, and looks out over the river and the terrifying drop to the gorge below. People claim to have been drawn to the windows at this spot by an 'irresistible' force and Lachie told me how the room is said to be haunted by the ghost of a servant who was thrown out of the window by Cromwell's men for refusing to betray the family's hiding place. He said that strange tapping noises had been heard on the windowpanes at night and the spectre of a grey lady also haunts the room.

Lachie told me how all through his childhood his imagination had been inspired by visits from his aunt Mona, who was a great believer in fairies, and he showed me some curious and beautiful paintings that she had done of 'her friends' as she described them. In recent years the only experience that has frightened Lachie at the hall took place in the tower which is reputed to be haunted by an old family retainer. He said that he awoke one night to find 'something' pushing down on his chest, a terrific weight, squeezing the breath from his body, but somehow he managed to fight it off. He says that he feels more at ease in the castle now and later in the evening lent me a book by a Chinese philosopher which he said had been an inspiration to him.

Lachie's father, the twenty-eighth Chief, lives in a cottage near the hall where he is writing a spy novel featuring the KGB. He also feels that the 'atmosphere' of the house has changed for the better, especially since it was exorcized three years ago by a Russian Orthodox

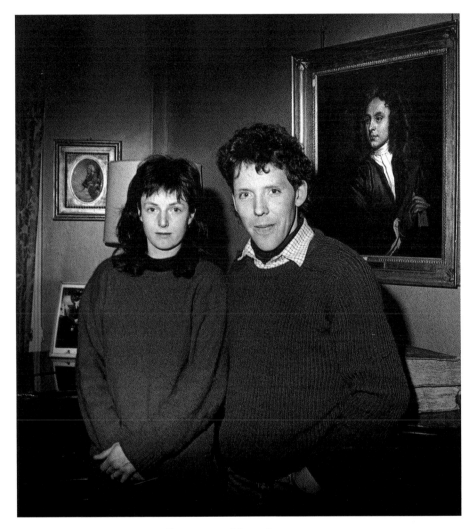

LACHIE AND NICKY RATTRAY

bishop. On hearing that I was to sleep in the North Room I accepted one last large whisky before saying goodnight.

The room seemed unnaturally cold so I quickly shut the window, undressed and climbed into the ornate four-poster bed, having been careful not to look out of the window at the drop below. Apprehensively I picked up a book and read a little more about the intriguing history of the Rattray family before falling asleep. The last words I remember was their family motto: 'Our hopes are beyond the skies'.

I awoke around six o'clock, freezing cold, and heard a rustling noise in the room. Terrified, I switched on the light only to see a small bird fly out of the window. Relieved, I got up to close the window, but as I returned to the warmth of my bed, wondered who on earth had opened it? I tried to go back to sleep but couldn't, then remembered that I had asked Lachie to wake me early, so decided to pack. He brought me a cup of coffee around seven and as he went back to bed I left for my next location, a long drive to the north of Scotland.

I left the house feeling slightly hungover, as well as a little uneasy, and I had to admit to a certain sense of relief as I started up the engine of my car and set off again down the long driveway. Then I remembered something that Lachie had mentioned over dinner the previous night: apparently the track itself is cursed and the man who built it died on the very day it was completed.

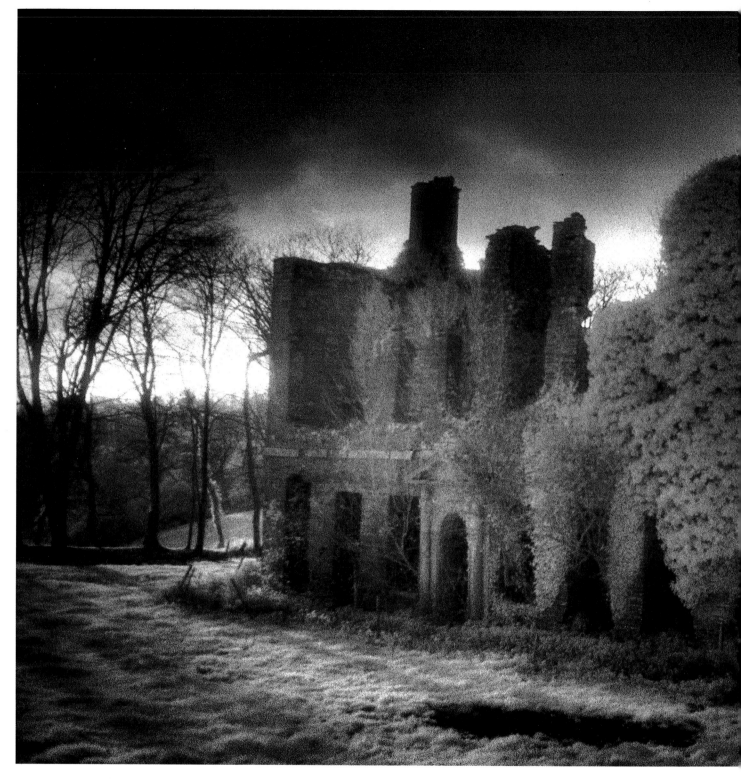

OLDSTONE HALL
Devon, England

My visit to this burnt out mansion, set in the undisturbed countryside of the South Hams, with its bizarre stories of murder and hauntings, was an unforgettable experience. I arrived by the back entrance; it was winter and had been raining hard. I turned into a narrow, pot-holed driveway, with sinister overhanging trees, which was a sea of mud. Suddenly, a tractor turned the corner in front of me and stopped. The farmer asked if he could help and I said that I would like to photograph the old house. He said yes, but that if I wanted to know something of its history, I should call at the farmhouse and ask his father.

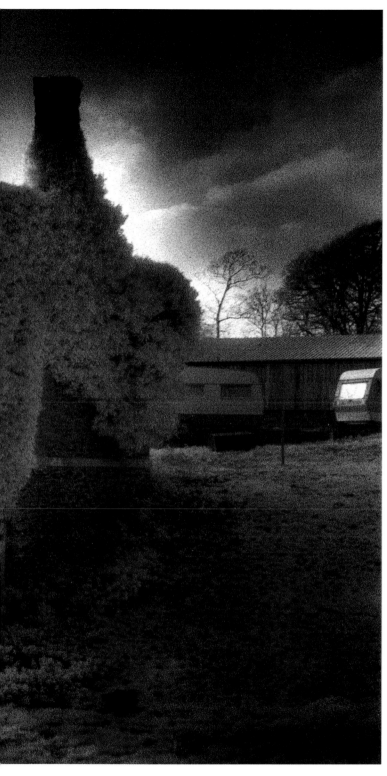

dated back to Saxon times, and his family had lived here since 1944. The hall itself was built in the eighteenth century on the site of a monastery by the Cholwich family, local wool merchants. In its heyday the grounds boasted three lakes, a grotto, many secret tunnels and a hermit's cave, all now in ruins. The house was then sold to Percy Dimes, a former steward of the Cholwich family, and it was then that a terrible disaster occurred.

Dimes had a beautiful daughter, Laura, who fell madly in love with a dashing New Zealander called Hugh Shortland, a trainee barrister. Her parents disapproved of her lover and he was forbidden to go near the house, and so the couple would meet in the woods nearby at the Monk's Pond. Also unknown to her parents they were secretly married. Then one morning, after taking her horse for a ride, Laura walked down to the woods, but never returned. Later, her riding hat was seen in the pond, about three inches appearing above the water and close to the bank. Bizarrely, her dead body was directly beneath the hat, standing bolt upright. Shortland was arrested on suspicion of murder. He denied the charge, defended himself in court, and was acquitted. What really happened, whether it was murder or suicide, remains a mystery.

Her parents were broken-hearted and some ten years later the house was mysteriously destroyed by fire. The family had always been convinced that Laura's ghost haunted the house and had named one room 'The Ghost Room' after a chimney-sweep had seen something terrible high up on a wall. When the house burnt down only this room survived intact. Poor Laura's ghost is still seen close to the ruins. The old man added that they had seen other phantoms including 'something' that would appear crouching on top of the old arch near the farmhouse, and his son had seen the ghost of a little man with a long grey beard and pointed chin, who was dressed in Edwardian clothes.

His son later came in and confirmed this story, saying that the spirit came through the wall, walked up on to his bed, then disappeared through the ceiling by the light fitting. Soon afterwards a hail of stones beat down on the roof continuously for about ten minutes. It was time for me to leave, the sun was setting over the decaying arch. I passed beneath it in trepidation, unable to walk as fast as I would have liked in the thick mud.

I parked in the farmyard and walked down to the ruin. The wind was howling through the skeletal trees that surrounded the house and dark clouds were racing across the sun, which sporadically lit up the ivy-covered hall in all its ghostly magnificence. As soon as I had finished I hurried back up to the farmhouse, eager to hear of its dark secrets. An old man slowly opened the door and, while his daughter made us a cup of tea, he began to talk of the past. Some of the farmhouse walls

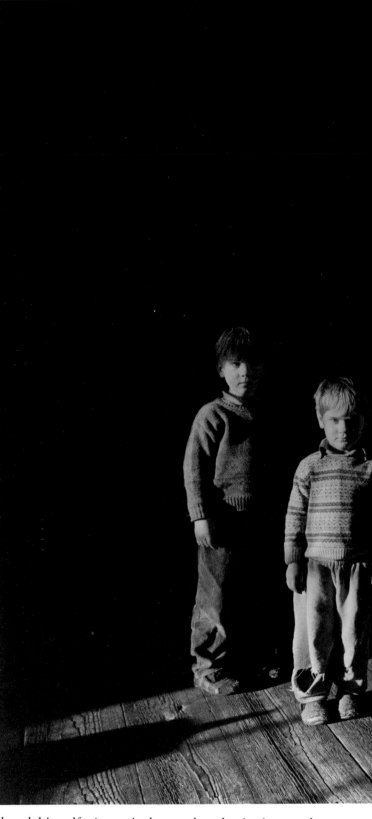

13 HENRIETTA STREET
Dublin, Southern Ireland

When Henrietta Street was originally built it was the most prestigious address in Dublin, but now many of these fine Georgian houses lie in virtual ruins. In its heyday the grandeur of the street attracted important society figures, from archbishops to aristocrats. No 13 was the town house of Viscount Nicholas, Lord Loftus, the first Earl of Ely. It is now the home of Michael and Eileen Casey and their five children.

I approached the street on a very cold but beautiful winter's day, the clarity of the sunlight breathing new life into the decaying buildings, which shone with a surreal glow. As I walked up the street I somehow felt that I was part of a predetermined dream, that I could knock on any door and be part of any fantasy I might imagine, it was one of those days where everyone appears to meet as if by accident.

The litter in the street and the graffiti on the walls could not detract from the beauty of the houses, each doorway a work of art in itself, as so many in Dublin are. I was filled with excited expectancy as I knocked. The door was opened almost immediately and I was confronted with a small boy clutching a broom handle for a sword and a battered old tray as a shield. I presented myself and he told me that his mother was ill in bed, but that his father was expecting me and would be home soon. He then showed me through the hall into a large room where two of his brothers were defending a castle made out of upturned chairs.

I asked the boys if it was alright for me to look around the house and the eldest shouted yes as their battle raged. The rooms were mostly large and the furniture was sparse. On some walls the brickwork was showing and throughout the paint was peeling off the walls and ceilings in strangely perfect patterns, like priceless works of art. On other walls poignant literary graffiti were written in chalk next to imposing ancestral portraits. Marble busts and statues stared back at me from various corners and piles of antiquarian books lay on dusty tables next to tableaux of seashells, old toys and daguerreotypes. The whole effect was one of inspired imagination and elegant decadence.

At this point Michael Casey returned and introduced himself. An articulate and enthusiastic man he was born on Hallowe'en and works as a special effects technician in films. He was soon telling me his family history. The Caseys had been merchants of the city, associated with the wine trade and had lived in Fishamble Street since the 1840s — Michael's father and

[58]

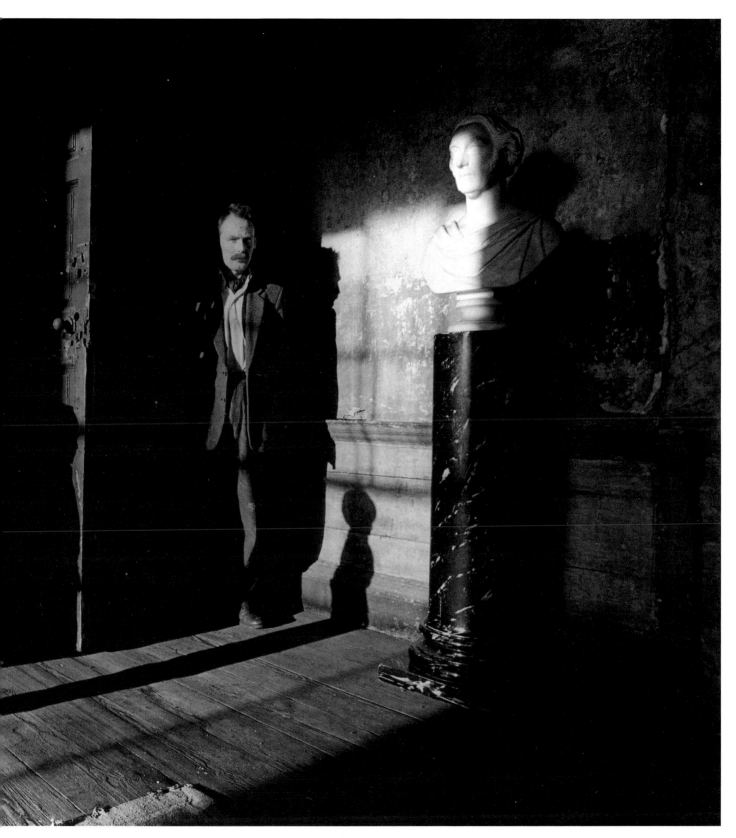

uncle still live there now. It was in fact here that he had had his most unusual supernatural experience.

It was on a sunny April day in 1971 at around noon when he heard horses outside in the street. He thought this strange and so went out to investigate, where he saw two men dressed in eighteenth-century clothes, wearing wigs and pushing a coach. He ran back inside to tell the rest of the family, but when they came out the vision had gone. He thought it all the stranger because it was in broad daylight. What also interested him was that this experience had taken place on the fiftieth anniversary of the first performance of Handel's

Messiah in Dublin, at the Fishamble Street Theatre, 23 April 1741, and there had been a dress rehearsal at midday before the evening performance. It is also interesting to note that the theatre was long reputed to be haunted too, before it was demolished at the end of the nineteenth century.

At this point Michael's uncle joined us. A sensitive, quietly spoken man, his passion is collecting death masks and he spoke of his own uncanny experiences in 13, Henrietta Street. He had stayed here alone seven years ago when his nephew was abroad and had frequently sensed that someone or something was standing in a corner at the top of the back staircase. Michael said that he had also felt a 'presence' here. Apparently their neighbour said that she often saw from her window a lady in old-fashioned clothes standing in the hall, but the priest had been to 'lay' this ghost.

It is not surprising then that, with such a history, other houses in the street are also said to be haunted, including one where the ghost of a serving girl re-enacts her death by jumping from a fourth floor window. Before I left I explored this fascinating house once more and wrote down this particular piece of inspirational prose from one of the walls:

> The man of genius bears upon his brow a kind of mark of Cain by which men recognize him – and having recognized him, generally stone him.
>
> *Aldous Huxley*

INTERIOR, 13 HENRIETTA STREET, DUBLIN

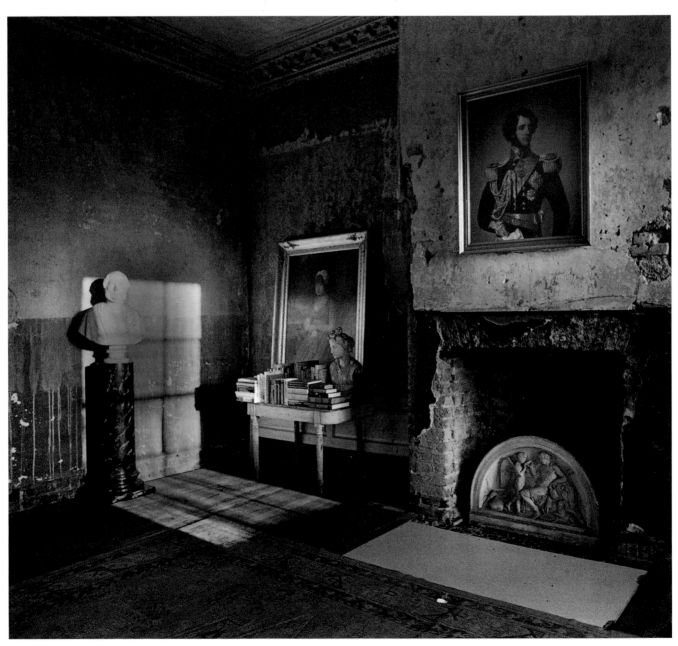

JULIAN'S BOWER
Alkborough, Lincolnshire, England

A tradition of mystery and romance surrounds the ancient mazes and labyrinths of the world, whether it be the mythology of the Cretan Labyrinth, where Theseus supposedly slew the Minotaur, or the later adoption of the maze pattern by the early church as a symbol of the Christian path to salvation. It is thought that this turf maze was first cut by monks from nearby Walcot and it would have been used in Elizabethan times by the village children to play on. Turf mazes often bore the name of 'Julian's Bower' or 'The Walls of Troy' and it is supposed that these names record the belief that Julius, son of Aeneas, the legendary founder of Rome, brought these maze games back to Italy from sacked Troy.

The ghostly but joyful sounds of children singing and shouting, echoing from the deserted maze, have been reported over the years, and when a retired archaeologist and his family visited the site in 1973 one of his young children began to behave very strangely and burst into tears. When his mother asked him what the matter was he replied: 'They won't let me play with them.' 'Who do you mean?' she asked. 'The little children in funny clothes,' he replied with a hurt expression. 'I don't know how to play their game.' There was no one else there but his parents and elder brother.

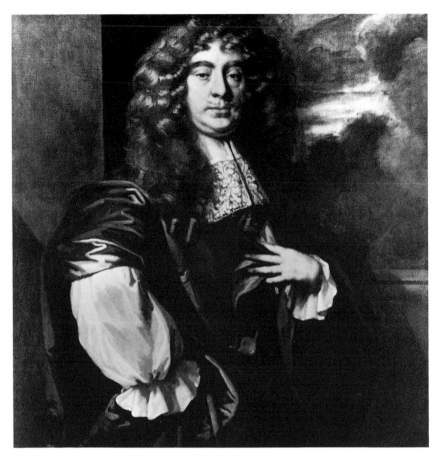

JOHN MAITLAND, DUKE OF LAUDERDALE (1616–82)
(Victoria & Albert Museum, London)

THIRLESTANE CASTLE
Berwickshire, Scotland

One of the oldest and finest castles in Scotland, Thirlestane is the ancestral home of the Maitland family, Earls of Lauderdale since 1590. One of their distinguished number, the powerful and controversial figure of John Maitland, the second Earl (1616–82) and later created the Duke of Lauderdale, is still said to haunt the castle. A staunch Royalist and close friend of Charles II he fought alongside the king at the Battle of Worcester in 1651. He was captured there and spent the following nine years in the Tower of London under sentence of death, but was released at the Restoration and then made Secretary of State for Scotland. Described as a large, rough and boisterous man with an intelligent mind, but a coarse and arrogant manner, he wielded such power that he was virtually the uncrowned king of Scotland. But he began to misuse this authority, making many enemies, and King Charles II was reluctantly forced to ask him to resign.

Local people had lived in great fear of this larger than life tyrant and rumours of his excessive drinking and womanizing were rife. His first wife died at the age of twenty-seven and within six weeks he married the notorious Elizabeth Murray, Countess of Dysart, (**see** Ham House, Richmond) who was suspected of murdering her previous husband. She married the ruthless duke to further her ambitions while he was completely infatuated by her. Together they began to turn the castle into a palace fit for the duke to rule Scotland from, but the marriage was stormy, and on one occasion Lady Dysart is said to have left for London taking away fourteen coachloads of furniture from the castle.

The duke's restless spirit is also said to inhabit St Mary's Church at nearby Haddington, where he was buried in the vast Maitland family vault. His funeral was a grandiose ceremony attended by over two thousand horsemen and a large leaden urn containing his brain and intestines was interred next to his ornate coffin. When the great iron door to the tomb has been opened in later years the coffin has always moved, adding to his awesome reputation.

SKRYNE CASTLE
County Meath, Southern Ireland

The magic Hill of Tara was once the religious, political and cultural hub of Ireland. The now lost palaces of the High Kings dating back to the third century AD were sited here. Here too skeletons have been unearthed in passage graves under Tara dating back to 2,000 BC and earlier. A companion hill known as *Gnoc Ghuil* or 'The Hill of Weeping' stands nearby, and it was on the southern slopes of this powerfully atmospheric site that the Norman knight Adam de Feipo built Skryne Castle towards the close of the twelfth century. After changing hands several times, the castle fell into disrepair, but was restored in the early nineteenth century when the present house was built around the old keep; and the thickness of its walls proclaims the age of the ancient tower today.

It is little surprise that the castle and its beautiful grounds, situated in such a mystical and sacred spot, are reputedly haunted by several apparitions that include a nun and a tall, cloaked figure and his dog. For who can ever know the dark secrets of the many generations that have lived and worshipped around this spiritual domain? But it is the spectre of a woman in white and the ghastly shrieks that have been heard echoing through the castle at dead of night that have given it such a ghostly reputation.

On the sudden death of her parents in a tragic accident at the start of the eighteenth century, a shy young girl named Lilith Palmerston had come to live at the castle as a ward of the then owner Sir Bromley Casway. Her guardian suffered from chronic gout and was confined to a wheelchair and this meant that Lilith had to give the old man her undivided attention. His eyesight was also beginning to fail and he demanded that she read to him his favourite tales of the mysterious East and darkest Africa, whose ancient customs held such a fascination for him. In due course Lilith was sent away to a fashionable school in Dublin where she blossomed into a beautiful young woman but, instead of allowing her to experience the allure and excitement of Dublin society, Sir Bromley demanded that she return to Skryne to nurse him.

Poor Lilith became a virtual recluse in her own home, her beauty and youthful vivaciousness wasting away. Then one day when out walking near the castle grounds she met by chance a neighbouring Squire called Phelim Sellers, an arrogant and brutish man, who was instantly attracted to her. She was both frightened and repulsed by his lust, discovering later that he had mistreated his young wife, who had died in suspicious circumstances. The Squire now visited the castle frequently, under the pretence of playing cards with Lilith's ailing guardian, but all the time undressing the curvaceous girl with his eyes. Then on one hot summer's day, when he was the worse for drink, he followed her out into the garden and lunged at her, tearing open her dress, but Lilith was too quick for him and ran off screaming into the woods.

Shocked and terrified by her ordeal Lilith pleaded with her guardian to allow her to return to Dublin and stay with friends, but was too terrified to tell him what

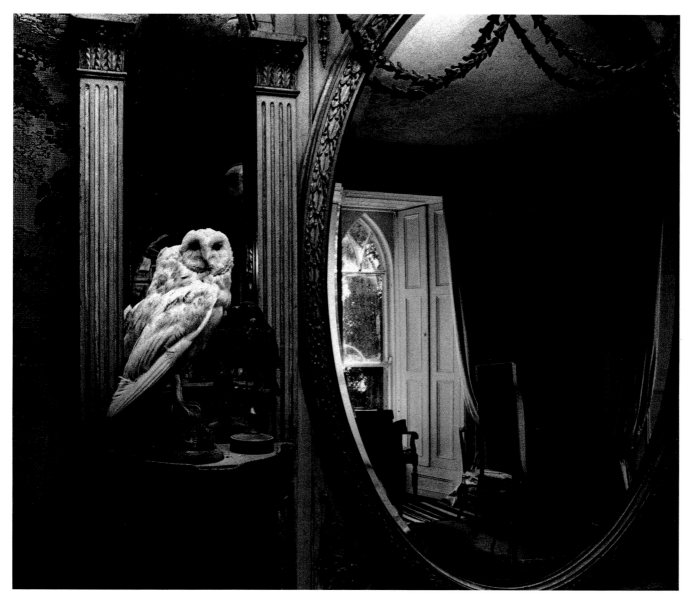

THE DRAWING ROOM, SKRYNE CASTLE

had happened. Reluctantly he gave in, but Sellers got to hear of her departure from a maidservant, and on the night before she was to leave Skryne he forced entry into the castle and tried to rape her in her room. In the course of the struggle he strangled her and, although he managed to escape, he was later captured in Galway City as he was about to flee the country by ship, and was hung in the gaolyard at Clew Barracks. It is poor Lilith's ghost that is seen roaming the castle grounds in a long, torn nightdress, her hands clutching her throat, and it is her awful shrieks that echo through the corridors of the castle at dead of night.

Today Elizabeth Hickey, a respected local historian, lives at the ancient castle. She seems quite at home with the spirits and says that her interests lie more within the realms of historical fact than the world of the supernatural. After we had discussed the history of the castle and its ghosts she courteously showed me around the evocative interior. As we entered the drawing-room, where the superb furnishings and ancient artifacts immediately held my attention, Mrs Hickey offered me a cup of tea saying that she had some writing to do and would I excuse her for a while? As I wanted to take some photographs in the house I returned to my car to fetch my cameras.

On my return I was still deep in thought over all that she had told me about the castle and time must have passed very quickly, for I suddenly noticed that the light was beginning to fail. Then, on entering the drawing-room again, I began to feel somewhat uneasy, the long curtains were gently rustling in the evening breeze and sombre shadows were slowly creeping across the walls and floor. It was as if the tenuous veil of everyday reality was gradually being withdrawn from the darkening room, and that its ghostly inhabitants were about to reveal themselves to me.

[65]

JEREMY BENTHAM
University College, London

One of the more bizarre sights of present day London is the skilfully disguised skeleton of the philosopher Jeremy Bentham that sits in a chair inside a glass case near the entrance hall of University College. Bentham, one of the founders of the College in 1826, was also respected for his philosophy of 'utilitarianism', based on the premise that 'the greatest happiness of the greatest number of people' should be the object of both individual and government action. Bentham also believed obsessively that the dead could continue to be of use to the living and he was known to have suggested to his friends that the embalmed bodies of their deceased relatives should be turned into ornate statues to adorn the driveways of their country mansions.

On his death in 1832 this eccentric man, true to his convictions, willed that his body should be first dissected in front of his friends, then the bones rewired together, that a death mask should be made, and the resulting body should be dressed in a suit of his favourite clothes. This effigy is still wheeled out once a year to preside over a dinner of distinguished medical doctors. But it is his ghost that is more frequently seen, by members of both the staff and students, as he continues to roam the corridors of the building that meant so much to him during his lifetime.

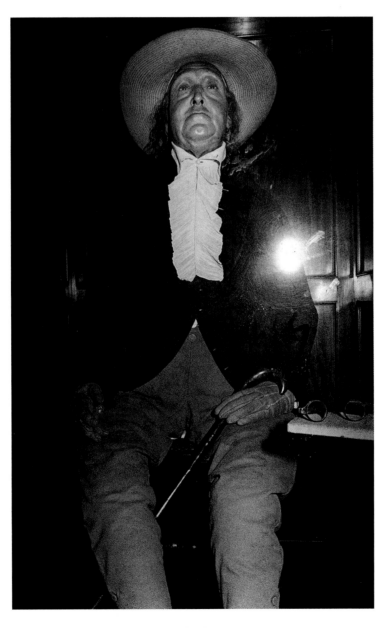

Sopwell Castle
County Tipperary, Southern Ireland

Several panes of broken glass still reflect the moonlight from the decaying windows of the castellated ruin of Sopwell Castle. Also known as Killaleigh Castle, it originally belonged to the MacEgans, but was confiscated by Oliver Cromwell in the seventeenth century, and given to a General Sadleir in his conquering army, from whose name it is believed that of the Sadler's Wells Theatre derives.

The castle is said to be haunted by occasional strange and unearthly sounds that are heard late at night. They have been described as loud crashes, a terrifying scream and the noise of 'something' being dragged down a staircase. No doubt the explanation for these 'vibrations' is to be found in a story surrounding the death of a later member of the Sadleir family, which was recounted to me by Gilbert Webb of nearby Corolanty House.

It is said that when this Sadleir was on his deathbed he expressly forbade his only son to hold a 'wake' for him when he should finally be called to meet his maker and the young man agreed. However, an old friend of the father's, Sir Thomas Dancer of nearby Modreeny House, who was partial to a good night's drinking, managed to change the son's mind. At about four in the morning they were both in high spirits and decided to carry the coffin down the stairs to the church for the funeral service that afternoon. Unfortunately one of them tripped, the coffin fell and the lid flew open to reveal the old man – still alive and very angry. So angry that, instead of being grateful for being saved from the grave, he disinherited his son and gave the castle to his daughter Mary. She later married into the Trench family, which ironically meant that the estate passed out of her family's possession.

GLAMIS CASTLE
Angus, Scotland

This grim and menacing fairytale castle was built on a site that was believed since early Celtic times to be the sacred abode of ancient spirits of the earth and air. The fortress is steeped in history and is said to be peopled by a legion of ghosts and, as one enters the spectacular demesne, through the awesome 'Devil Gates', and continues down the long avenue towards the castle, with its many baronial towers commanding the skyline, the words of the romantic Scottish novelist Sir Walter Scott, who once stayed the night here in 1793, come back to haunt one. 'I must own,' he wrote, 'that when I heard door after door shut, after my conductor had retired, I began to consider myself as too far from the living, and somewhat too near the dead.'

Thought to be the oldest inhabited castle in Scotland, this has been since 1372 the seat of the Bowes Lyon family, later Earls of Strathmore and Kinghorne, and is the childhood home of the present Queen Mother. There are over ninety rooms in the castle, many left empty, but it is the legend of the 'Secret Room' and the 'Monster of Glamis' that has given the castle its widespread notoriety over the years. It is said that at some time towards the beginning of the nineteenth century a monster was born to be the heir of Glamis. This poor, misshapen creature, more like a toad than a man, was said to be immensely strong and was imprisoned in a secret chamber somewhere within the fifteen foot walls of the castle. The awful secret of his whereabouts and exact identity could only be known to three people, the then Earl, his next eldest son on his coming of age, and the factor of the estate. The mystery remains to this day, although rumours have circulated that the unfortunate monster, having achieved a great age, died in 1921, but there seems to be no record of his death. Lord Halifax, in his famous *Ghost Book* (1936) tells of large stones with rings in them in several bedroom cupboards, that were later made into coal stores to deter inquisitive guests, and of a workman who unsuspectingly uncovered a hidden passage near the chapel and who, after lengthy interrogation by his superiors, was induced to emigrate with his family. An area on the roof of the castle is still known as the 'Mad Earl's Walk', but whether this was used for exercising the monster at night or referred to another member of the family is not known.

Another version of the story claims that, due to an ancient family curse, a hideous vampire is born into every generation of this haunted family, which must be continually imprisoned to curtail its unquenchable thirst for human blood. Whatever the truth of the legend it is hard to ignore the reputed words of the late fifteenth Earl: 'If you could only guess the nature of the secret, you would go down on your knees and thank God that it was not yours.'

Lady Glamis, the beautiful widow of the sixth Lord Glamis, was controversially burnt alive as a witch on Castle Hill in Edinburgh in 1537, and her ghost, surrounded by a reddish glow, has been seen hovering above the Clock Tower. It is said that it was only after her death that the many supernatural phenomena began to plague the castle. In the oldest part of the building is Duncan's Hall, traditionally the scene of the murder of King Duncan by Macbeth, Thane of Glamis, in

THE CRYPT, GLAMIS CASTLE

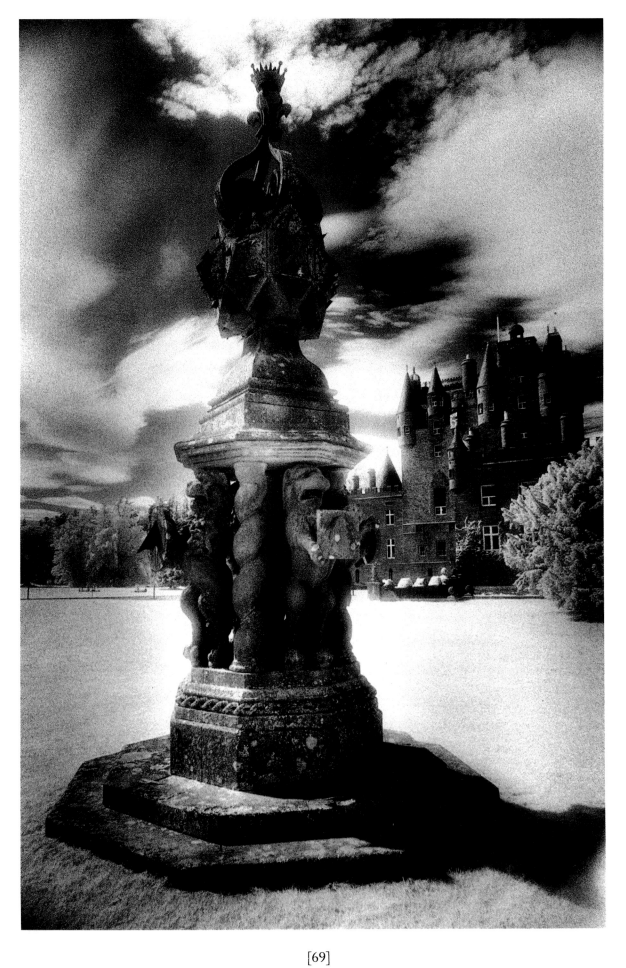

PATRICK, THIRD EARL OF STRATHMORE AND
KINGHORNE (1643–1695)

Shakespeare's grim tragedy. Lady Elphinstone, the Queen Mother's sister, is said to have been frightened by the sinister atmosphere of this room when a young girl. In another room of the castle King Malcolm II of Scotland was said to have been murdered and as his bloodstain was indelible, the floor was boarded over. Another horrific apparition is that of the pale face of a terrified young girl, seen staring from a barred window of the castle. She is said to have had her tongue cut out and her hands amputated at the wrist because of some terrible secret she discovered. There is also the spectre of a small mischievous boy, a negro servant, who frequently appears to visitors in the Queen Mother's sitting room.

But one of the most gruesome tales is that of the 'Haunted Chamber', said to be somewhere within the ghostly crypt. Members of the Ogilvy clan sought shelter at the castle during a feud with their enemies, the Lindsays, and were permitted to hide in this remote dungeon. The then Lord Glamis had the room bricked up and the unfortunate men were starved to death. It is said that when the chamber was opened over a century later their skeletons were found strewn across the floor,

some in such a position as to suggest that they died literally gnawing the flesh from their arms and terrifying poltergeist noises were said to originate from this part of the castle late at night.

I met the present day factor, or curator, who was reluctant to discuss the monster legend, and so I did not press him. He did however take me outside to show me a barred window off the crypt, which he said was believed to be a secret room. I was fascinated by the many impressive family portraits throughout the castle, none more so than the strange painting of the third Earl by the Dutch artist Jacob de Wet and the bizarre dress of this flamboyant nobleman. The overall sense of power throughout the rambling pile, the size and number of the vast rooms and dark passageways, was without doubt intimidating and I felt disturbed by so many suggestions of the unknown.

On my way back to my car I passed the tall, ornate sundial, with over eighty faces, and reflected on how everything about Glamis seemed somehow extreme. I came away with a sense of wonder, glad to have experienced this unique castle, but I would hesitate to return.

CASTLE DALY
County Galway, Southern Ireland

The remaining façade of this eerie house lies perched on the side of a hill near Loughrea. It has the uncanny appearance of a huge raven about to flap its wings and disappear into the mercurial Irish sky. It was once one of the several homes in County Galway of the mighty Daly family – whose main seat was at Radford – the Dalys being of pure Irish pedigree and related through marriage to some of the most influential families in Ireland. Peter Daly purchased the house in 1820 from the Blake family. It was then called Gorbally House but he renamed it Castle Daly.

According to a local man the Dalys held many great balls and house parties here and it is said that on some nights the house comes alive again with the sounds of music and laughter, as in times gone by. More ominous though are the cries of terror and anguish that then follow this phantom revelry.

Rumour was rife that many years ago the skeleton of a man, presumed to have been a servant, was discovered at the foot of an old well near the house. Beneath his body lay a quantity of Indian jewellery and the statue of an ancient God. What sinister secrets lie behind these tales are now forever abandoned to the mists of antiquity.

BOLESKINE BURIAL GROUND
Loch Ness, Scotland

I was driving along the eastern shore of Loch Ness on a grey, rainy day and my thoughts were of the monster that is said to lurk within the murky waters of the lake. I was remembering the theory of the old abbot of the Benedictine monastery at nearby Fort Augustus, that this creature was not merely a prehistoric animal but an 'embodiment of all that is evil in the world', when suddenly I noticed a mysterious old cemetery by the shore of the loch.

I stopped the car and walked into the graveyard. The ancient tombstones were memorials to various clan members, mostly Frasers, and the whole enclosure had a particularly strange atmosphere, as if it were the centre of some powerful force. I took several photographs but had to move on as I was late for an appointment. As I

[72]

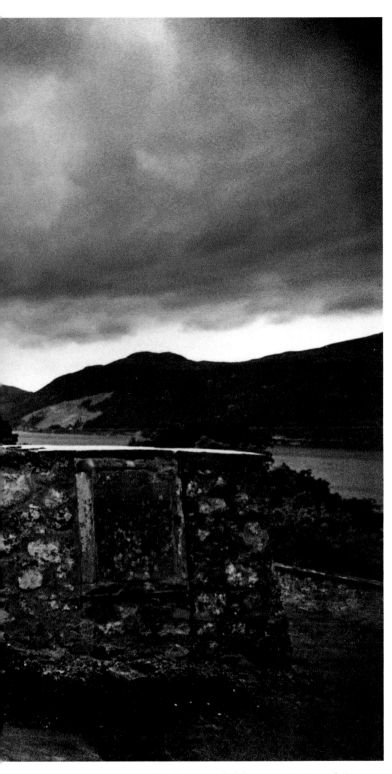

ALEISTER CROWLEY, 'THE GREAT BEAST 666' (1875–1947)
(Hulton–Deutsch Picture Company)

was obscure. He added that this particular burial ground had long been reputed to be the haunt of witches. But what he thought would interest me most was that Boleskine House had once been the home of Aleister Crowley, the notorious author, magician and drug addict, who liked to be known as 'The Great Beast'. Here he celebrated the Black Mass and indulged in various obscene rituals. It is said that Crowley unleashed evil spirits that ran amok in the area and the local people were utterly terrified of him. There were stories of people being driven insane and of others dying in mysterious circumstances.

One horrific story describes how several people visited the house after he had left and entered his secret chamber where one of them blew on a ceremonial goat's horn that they found there. This was said to have set off an inexplicable and demonic chain of events in the district. It would seem that Crowley must have either known of the area's dark forces, or had tragically summoned up ancient spirits that even he had never dreamt of.

was leaving I noticed some children's paintings lying on the ground. They had been torn from a noticeboard where the glass had been smashed. The images were of witches, skulls and ghosts, but I couldn't read the writing as the ink was slowly dissolving in the rain.

Later that evening my host told me that the churchyard was in an area which had been dominated by the Fraser clan since the fifteenth century, and had been the scene of many clan atrocities, but that the history of the region in the dark ages and medieval times

CULVERTHORPE HALL
Lincolnshire, England

I can remember when I was young my father telling me about a large old house in Lincolnshire where, at the age of twenty-one, he had stayed over a weekend for a dance that was held for one of the four daughters of a General Adlerchon. On the Friday evening, the night before the ball, he was climbing the main staircase when he passed a beautiful young woman coming down the other way. He had never seen her before and noticed the sad expression on her face. At dinner he asked his host who she was as he couldn't see her in the room, but the general replied that none of the other house guests were arriving until the next day and that he must have seen a ghost.

My father is now dead, but recently I discovered that the house in his story is Culverthorpe Hall, near Grantham and that two of the Adlerchon girls are still alive. The eldest, Lillias, whose dance it had been, lives in California but was fortunately visiting her younger sister Pauline in England for Christmas. Pauline and her husband live about fifteen miles from Culverthorpe now and very kindly asked me to Sunday lunch to discuss their former home and its ghosts.

They told me that there had been a house at Culverthorpe from the time of the Norman Conquest, but that the present house was built between 1690 and 1730 by the Newton family, who were cousins of Sir Isaac Newton (1642–1727) the eminent scientist, alchemist and Grand Master of the Rosicrucians, who formulated the laws of gravity and was born at Woolsthorpe Manor nearby. He was very friendly with his cousins and visited Culverthorpe many times.

In 1730 Sir Michael Newton had married the beautiful Margaret, Countess of Coningsby, who was an accomplished horsewoman and renowned for always wearing blue. Pauline thought that it was probably her remorseful ghost that my father had seen, for a great disaster had befallen the young couple with the bizarre and horrific death of their infant son. It was fashionable at the time to keep a tame monkey as a pet and the Newtons, who owned a splendid house in Soho in London, prided themselves on being abreast with the latest styles. It was only two months after the birth of their son, when they were away in London, that the tragedy is said to have occurred. Apparently the monkey had seized the poor baby from its cot in a fit of jealousy, carried it out onto the balcony of the house and dropped it onto the flagstones below. The couple were devastated; Sir Michael died a broken man in 1743 and, as he had no male heir, the family line expired with him. Lady Newton always blamed herself for the child's death and it is her grieving ghost that is said still to haunt the house.

The hall then changed hands several times and was

finally left empty for many years until its occupancy by the girls' father, Brigadier General Laderveze Adlerchon, in 1910. Up until then he was not a believer in ghosts, but Pauline remembers how one night he went up to the old Newton nursery, which was being renovated, to see how the work was progressing. There

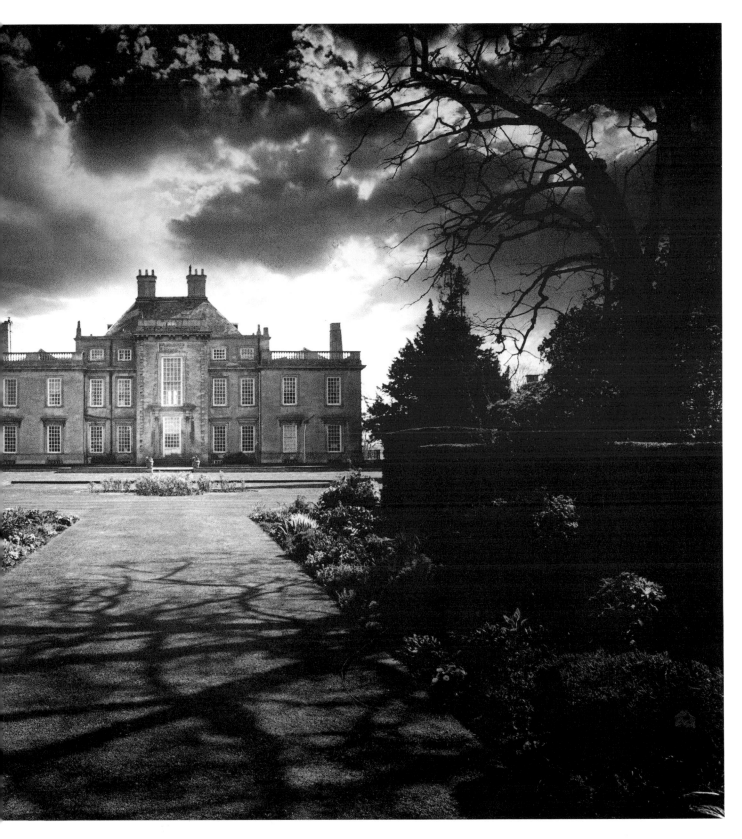

he saw the extraordinary apparition of a ghost in two parts: the ankles and lower legs on one floor and the rest of the torso on the next. It was a man with a turban wound around his head, a common practice of gentlemen in the eighteenth century when they took off their wigs at night. Both sisters remembered that during their childhood the ghost of the 'Blue Lady' was seen by several people, including the gardener's wife, Mrs Robinson, on the lawn in front of the house in broad daylight.

Later, Lillias began to tell me of her experiences. When not quite three years old she would be put

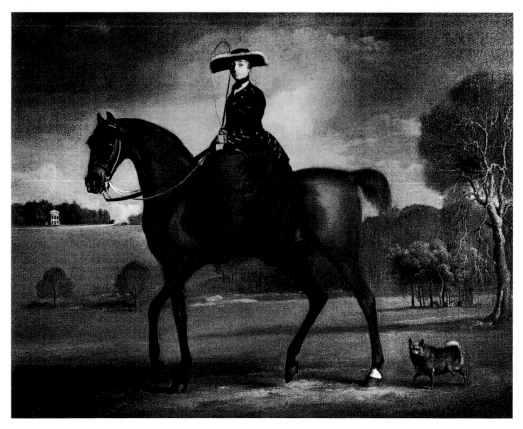

THE COUNTESS OF CONINGSBY c1760
(Paul Mellon Collection – Yale Centre of British Art)

outside in the garden for a rest in an old canvas cot during the summer mornings. The sides of the cot were about eighteen inches high and every day a small being would come up and peer over the edge at her; he was not dressed in clothes but was covered in hair and had a greyish, almost human face, only disappearing into the nearby bushes when her nanny's white cap would appear on the horizon. The experience was very real to Lillias, but she could not make herself understood at the time as people just laughed at her. In later years she thought that this 'thing' was perhaps an escaped lunatic from the asylum at Rauceby some two miles away. The place where she was put to rest was a hollow beneath an old ash tree and she was literally terrified of this area until at the age of five she actually saw the tree blown down, as if in slow motion, during a violent storm, and this gave her a great sense of relief. The area has since been filled in and made into a tennis court. Lillias had also slept in the room that had been the Newton's former nursery and had frequently heard the Countess' voice pleading to come in at night, but had never seen her ghost.

I later drove over to the hall to take photographs, where the present owner says that he has not yet had the pleasure of meeting the ghosts, but showed me an old overgrown lake known as the 'Monkey Pond'. Later, whilst exploring the rear of the house, I met the gardener, who had known the house for over forty years and remembered how there used to be a large portrait of the Devil in the main hall. Surprised, I asked him whether it was a painting or a carving. He said he didn't known about such things, all he knew was that it was very black.

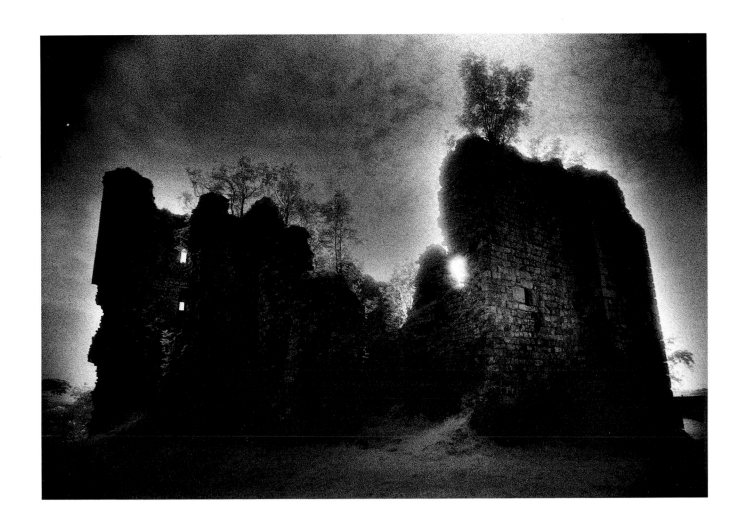

THIRLWALL CASTLE
Northumberland, England

This romantic ruin, lying close to the Scottish borders, is said to contain within its broken walls a fabulous hoard of buried treasure that is guarded by a hideous, deformed dwarf. The castle was built in the thirteenth century with stones plundered from Hadrian's Wall, at a point where the Scots had pierced the Roman fortification. The ancient verb 'to thirl' means 'to pierce'.

The Barons of Thirlwall were, like so many other border families, fierce and renowned warriors and they rode forth from the castle to wars in Scotland and France. It was in the time of Baron John de Thirlwall that the legend of the buried treasure began. The baron had returned to the castle in triumph after a successful campaign in some bloody foreign war, and with him he brought a baggage train of booty that he had pillaged from his unfortunate victims. The pride of these spoils was a solid gold table and the baron appointed one of his retainers, a misshapen and horrifying dwarf with supernatural powers, to guard it. It was not long before rumours of these riches were rife in the borderlands and it was the Scots who finally stormed the castle one night, taking the defenders by surprise, and butchering every last man of them.

When the attackers reached the chamber where they knew the treasure was hidden, the table was gone. One of their number looked out of the window and saw the repulsive midget struggling to throw the table down a deep well. The attackers rushed after him, their swords drawn, but they were too late, as first the table and then the dwarf disappeared from view. The dwarf's distorted features were made more terrifying by an evil sneer as he cast a spell to seal the mouth of the well. A spell, it is said, that can only be broken by the coming of one who is the only son of a widow.

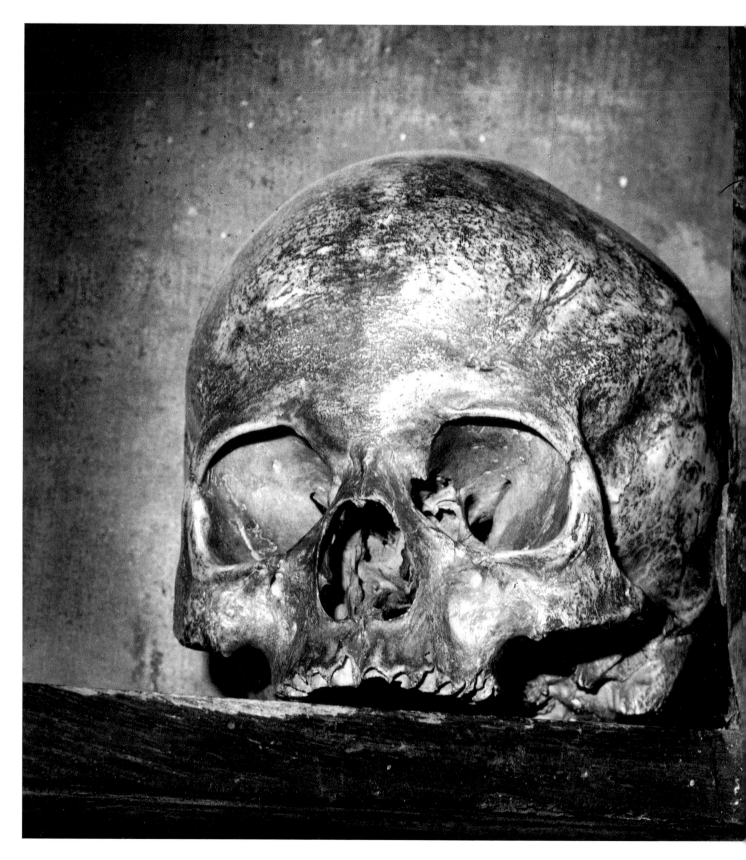

THE SKULL OF
THEOPHILUS BROME
Higher Farm, Chilton Cantelo, Somerset, England

It is hard to believe that this picturesque and peaceful English village could harbour such a macabre relic as the sinister skull that lies hidden away in an old wooden box at the ancient farmhouse. The house is owned by the Kerton family, whose ancestors have lived here since 1908, and Mrs Kerton told me that the skull is believed to be that of Theophilus Brome, originally from Warwickshire. He had taken up arms against King Charles I in the Civil War (1640-49) and after suffering serious wounds in battle, fled to Chilton Cantelo to hide with his sister, who lived at the farmhouse.

Brome recovered and remained undetected until his death in 1670. However it had become a common practice at the time of the Restoration in the 1660s for the bodies of those that had sided against the monarchy to be dug up, and for their heads to be cut off and displayed in prominent places in a spirit of revenge. Wishing to avoid this indignity Brome had pleaded with his sister to sever his head after he died and to keep it in the house, in perpetuity. She complied with his wishes.

The remainder of Brome's body is interred in the village church and marked by an inscribed memorial stone. The skull is kept in the oldest part of the farmhouse and Mr Kerton showed me some torn and faded parchment papers dated 1829 that detail the story and how, whenever later tenants had tried to bury it outside the house, horrific noises and supernatural phenomena had occurred. Mr Kerton believes that Brome's ghost is in the house but, although mischievous, it is a benign entity unless the house is disturbed or altered. In fact when they were redecorating the house at one point they frequently heard a man's heavy footsteps when nobody was there and things would go missing, to turn up eventually in unexpected places. Then, late one night, a barometer 'jumped' off the wall onto the stone floor but the glass miraculously didn't break. He also told me that about thirteen years ago the famous television personality Dave Allen came to record a programme on the skull but was very scared by something that happened to him later whilst driving home and told Mr Kerton he never wanted to return to the house. On another occasion, after a television crew had been filming the skull, that same evening a natural water well opened up suddenly in the garden as if, in Mr Kerton's words, 'Brome was trying to tell them something'.

As I later shook hands with Mr Kerton and got into my car to leave, I very much hoped that I was taking away with me nothing more than a photographic image of the skull.

CLONONY CASTLE
County Offaly, Southern Ireland

A decaying entrance gate casts a dark shadow towards the massive square tower of this early sixteenth-century castle. The little that is known of its history has proved controversial over the years. According to the eminent historian Thomas Cooke many skeletons, some Elizabethan coins, and several old swords, were unearthed here in the nineteenth century. But the workmen also uncovered something even more curious: a kind of cave in the limestone rock near a tree, about a hundred yards from the tower. In this cave, at a depth of about twelve feet and concealed by a pile of stones, they found a large flagstone which covered a coffin containing the bones of two women. The inscription on the stone declared that they were Elizabeth and Mary Boleyn, cousins of Anne Boleyn, the unfortunate wife of Henry VIII. How these two women came to be buried here has never been satisfactorily explained. It is known that their family had connections in this part of Ireland but nothing is recorded in connection with this particular castle. The site of the cave and the headstone can still be seen.

Anne Boleyn was beheaded at the Tower of London in 1536 at the wish of Henry VIII because of her inability to provide him with a male heir. She was accused of treasonable adultery with no less than five men, as well as sexual deviation, and on suspicion of being a witch for good measure. Her ghost is said to haunt no less than five different houses in England, including her picturesque birthplace of Blickling Hall in Norfolk. But the ghost of Clonony is that of a man, seen standing at the top of the tower in old fashioned dress, whose identity is a mystery. According to a Dutch industrialist – the last person reported to have seen this apparition while driving past the castle at night two years ago – 'he was tall, very thin, almost skeletal and he was surrounded by a hazy, luminous light as if he were on a stage.'

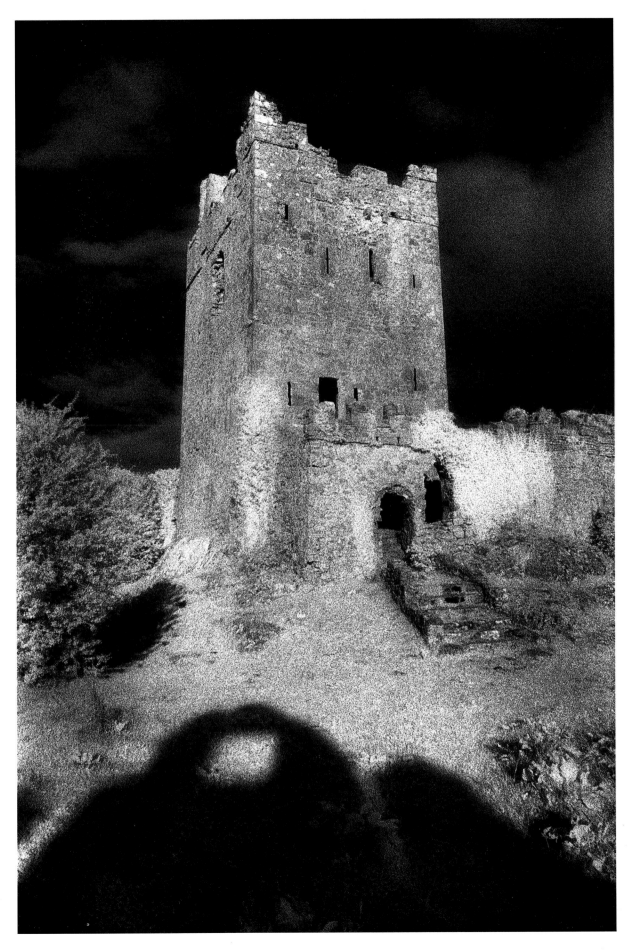

INVERARY CASTLE
Argyllshire, Scotland

Inverary Castle lies at the head of Loch Fyne, and for five centuries has been the ancestral home of the Dukes of Argyll and headquarters of the powerful Clan Campbell. Replacing an earlier fortified tower, it houses an impressive collection of armour, paintings and state rooms that reflect the rise in the clan's fortunes through military prowess, diplomacy and astute marriages. This made them unpopular with their fellow Highlanders, who either disliked their methods or were jealous of their success. Legend tells how, prior to the death of a chief of the clan, unusual numbers of dark ravens would circle the towers of the mighty castle, but a wider known and more dramatic portent was the ghostly galley, similar to the one on the Argyll coat-of-arms, that would sail slowly up the loch at night towards the castle, with three phantom figures at the helm, and within hours of this unearthly vision the chief would be dead. It is believed that this vision can only be seen by those with Celtic blood running through their veins.

Within the castle itself the Green Library is said to be plagued by loud crashes and other poltergeist activity caused by a phantom harper, who was hung by the strings of his own harp on the order of the Marquis of Montrose when he drove the then Lord Argyll from his castle in 1644. A member of the current staff told me that the ghost of a 'Grey Lady' has sometimes been seen outside the front of the castle on 'The Lady's Linn', a pathway near the bridge, but she did not know her identity.

As magnificent as the castle and the estate are, I was more inspired by the great loch, the dark hills and the ancient woods. The legend of the 'Galley of Death' seemed a more enduring vision than any symbol of man's transitory fortunes.

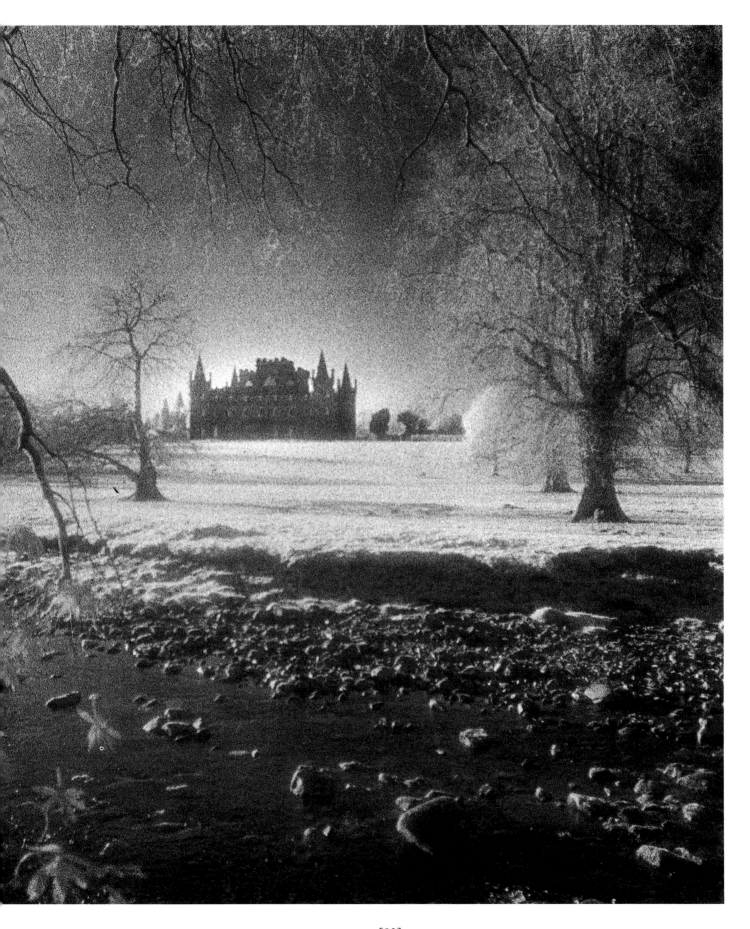

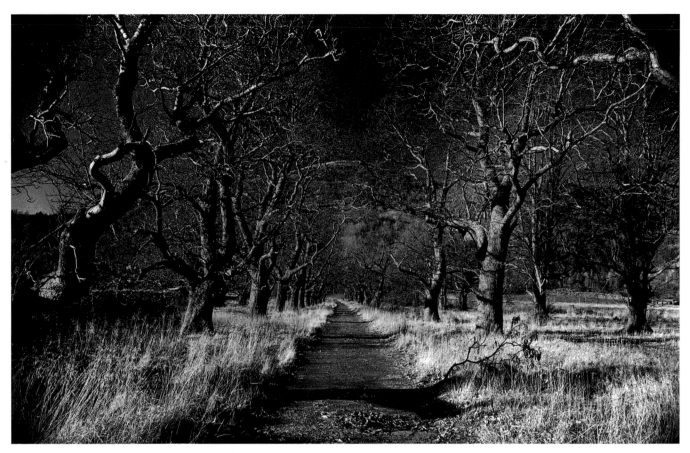

WOODS BY LOCH FYNE

LOCH FYNE

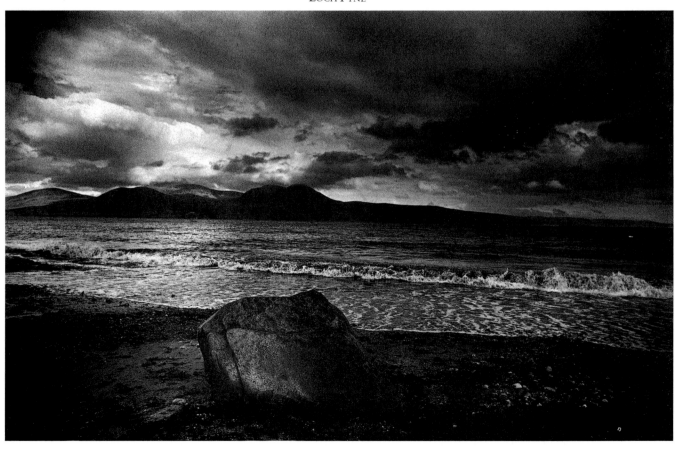

STATUE OF AN ANCIENT RIVER GOD, HAM HOUSE

HAM HOUSE
Richmond, London

London has the reputation of being the most haunted city in the world and this stately Jacobean mansion, which lies surrounded by trees beside the River Thames, is without doubt one of its most ghostly sites. Built in 1610 by Sir Thomas Vavasour, Knight Marshall to James I, the dominant ghost here is that of the notorious Elizabeth Murray, the Countess of Dysart, who later became the Duchess of Lauderdale.

A beautiful, bright, cunning and ambitious woman, Elizabeth had inherited the house on the death of her father, William Murray, as there had been no male heir, and was married to Sir Lyonel Tollemache in 1647. Unfortunately, he lacked the ruthless ambition that she expected from her men and long before his untimely death in 1669 she had begun an affair with the tyrannical John Maitland, the Duke of Lauderdale (**see** Thirlestane Castle, Scotland). After their marriage they embarked on a lavish lifestyle at Ham, completely redecorating the house at great expense, and many rumours surrounded the controversial couple, in particular that they were responsible for the imprisonment, torture and even

[85]

death of several people. The duchess was able to manipulate a number of powerful men of the time and it is said that she was a mistress to Oliver Cromwell. The duke died in 1682, the duchess outliving him by sixteen years, but she suffered so badly from gout in her old age that she was forced to walk with a stick.

The duchess' ghost is most often seen in the great hall or the chapel, and is always preceded by the macabre tapping sound of her walking cane at dead of night. There is a frightening story related by Augustus Hare, the Victorian author, concerning her ghost: apparently, the young daughter of a butler of the Tollemaches was invited to stay the night at Ham sometime after the duchess' death, and the young girl awoke in the middle of the night to find an old lady clawing and scratching at one of the walls in her bedroom. When she sat up, the old woman approached her bed and fixed a terrifying stare on the poor girl before disappearing. The girl screamed, and when help arrived explained what she had seen. The wall was examined the following day, and they discovered a hidden compartment containing some papers proving that the duchess had murdered her husband to marry the Duke of Lauderdale.

Other notable ghosts at Ham include a drunken cavalier and the endearing apparition of a small King Charles spaniel. After the Lauderdale's infamous reign the house was occupied by the Tollemache family for another three hundred years until it fell into neglect. Even today, although it has now been restored, it is as if time has stood still as one wanders past the statue of an ancient river god and through the house and grounds, which contain all the ingredients of the classic English ghost story.

ELIZABETH MURRAY, COUNTESS OF DYSART AND DUCHESS OF LAUDERDALE, WITH A BLACK SERVANT
(Victoria & Albert Museum, London)

[86]

HAM HOUSE

THE MERMAID OF ZENNOR
Cornwall, England

Tales of mermaids are represented in the folklore of almost every country across the globe, but perhaps one of the most famous of such legends is associated with the wild and beautiful Cornish coastline and the ancient church in the small hamlet of Zennor. On entering the church I was immediately struck by the strange figure carved on one of the pews: the 'Mermaid of Zennor'. She has long flowing hair and holds a comb in one hand and a mirror in the other, the symbols of heartlessness.

Many years ago the locals said that a stranger, a beautiful and richly dressed lady, used occasionally to attend services at the church. Nobody knew where she came from and there were long intervals between her visits, but on her arrival she would quickly become the gossip of the village. All the young men were entranced by her flirtatious charms and one of them, Matthew Trewella, the squire's son, who was particularly handsome and possessed the finest singing voice in the choir, had become enamoured of her and her seductive smiles. One day he decided to discover who she was

A MERMAID AND HER CAPTIVE
(Mary Evans Picture Library)

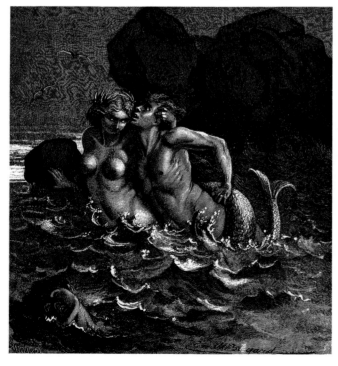

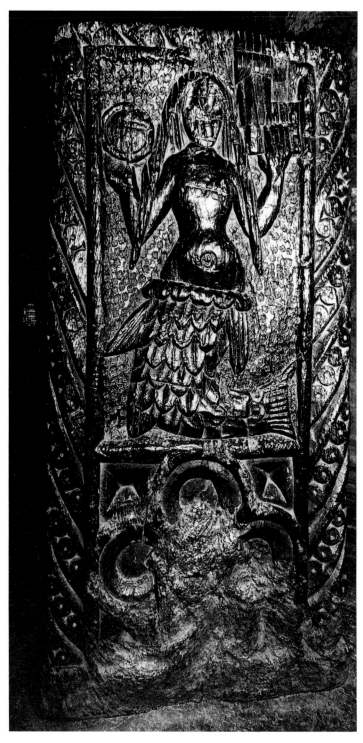

THE CARVED FIGURE OF THE 'MERMAID OF ZENNOR',
ZENNOR CHURCH

and where she came from, so after the service he followed her to the cliffs at nearby Pendour Cove. He was never seen again.

Some years later a ship's captain saw a mermaid in a nearby cove. She complained that his ship's anchor was lying across the entrance to her home and that she could not return to her lover, Matthew Trewella, and their children. The anchor was raised and when he returned to shore the captain informed the villagers of Zennor. They decided to carve the figure of the mermaid on the church pew as a warning to the other young men of the parish not to succumb to her wiles.

I walked down to the deserted cove where Matthew had disappeared, listening out for his ghostly voice that some say can still be heard, but I could hear nothing above the roar of the incoming waves.

ALLERTON PARK
Yorkshire, England

When I was young my family lived in Lincolnshire but my brother and I were sent away to a northern Catholic boarding school in Yorkshire and this meant that we were often driven past this extraordinary Gothic Revival house which lies next to the Great North Road between Wetherby and Boroughbridge. The fantastic mansion, with its dark and gloomy façade, is set back from the road behind high walls, and is encircled by lakes and follies that are overlooked by a classical temple on a hill. We rarely saw any sign of life near the building, no people or cars, yet it didn't appear to be deserted as sometimes there were lights on in certain windows. It was a house of mystery and I felt certain that it must be haunted.

When I asked various people who lived there no one seemed to know exactly, they had only heard rumours that ranged from it being used as a mental asylum to the headquarters of a fanatical religious sect, and so each time I passed my imagination would run wild, and the terrifying faces of the crazed and evil spectres that I dreamt roamed the long, dark corridors gave me endless nightmares.

Later, after I left school, I lived in London for a lengthy period of time and very rarely saw the house again, but if I did it still affected me in the same way. After the publication of my first volume of ghost stories, *The Haunted Realm* (Webb & Bower, 1986), which included many similar houses, I was continually being asked the same question: 'Why are you so obsessed by old ruins and haunted houses?' By including this house here, whether it be haunted or not, I hope that I can very briefly try and answer this question.

Almost certainly in this case I am projecting the ghosts that lie within me into the house because of a deep yearning in my soul for an alternative to a modern day world that is in the main dominated by the stifling cult of reason, that denies mystery and replaces it with a safe and shallow reality called civilization.

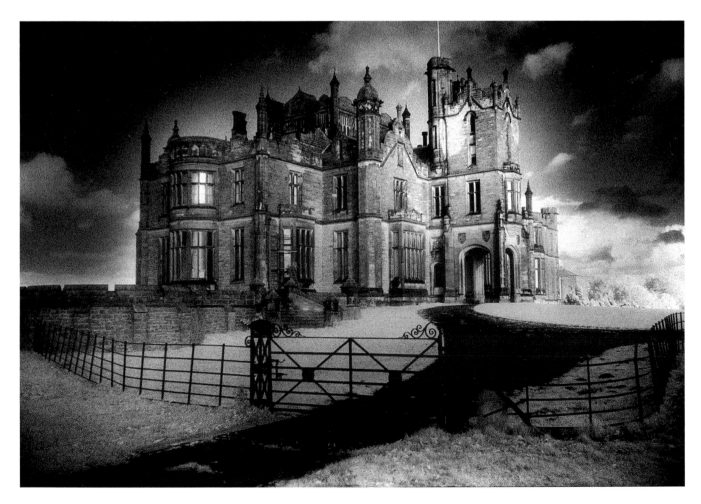

Westminster Abbey
London, England

Built by Edward the Confessor in the eleventh century, the magnificent abbey contains the largest and most important collection of monumental memorial sculptures in the British Isles. Here one can see the tombs of the legendary kings and queens of England alongside those of the country's finest statesmen, musicians, actors and poets. It is therefore no surprise that several ghosts are said to wander through these hallowed aisles, the most frightening of which is Father Benedictus. His tall, thin spectre is dressed in a monk's robe, his large domed head, with sallow skin, deep-set eyes and a protruding nose, peers out from beneath a cowl. He was stabbed to death with a lance when thieves broke into the abbey in 1303 to steal the king's treasure. He is most often seen in the cloisters between five and six in the evening, where he walks above the floor level. Another phantom is that of John Bradshaw who sentenced Charles I to death in 1649. His unquiet spirit haunts the deanery where he signed the death warrant.

But perhaps more frightening still than the vision of these apparitions is the startling tomb of Joseph and Lady Elizabeth Nightingale, sculpted by Roubiliac. According to Jill Waters in the book *Westminster Abbey – The Monuments*, she died at the age of twenty-seven as the result of a premature birth brought on by a fright caused by a flash of lightning. The monument shows her husband desperately trying to fight off the spectre of death. It is said that a robber who broke into the abbey one moonlit night was so terrified by this scene that he fled empty-handed, leaving behind a crowbar that can still be seen today.

I took photographs in the abbey very early one morning when nobody else was there and the sun was beginning to rise. It was an awe-inspiring experience to watch as the beams of light slowly crawled through the stained glass windows lighting up the effigies of so many distinguished corpses.

INTERIOR, WESTMINSTER ABBEY

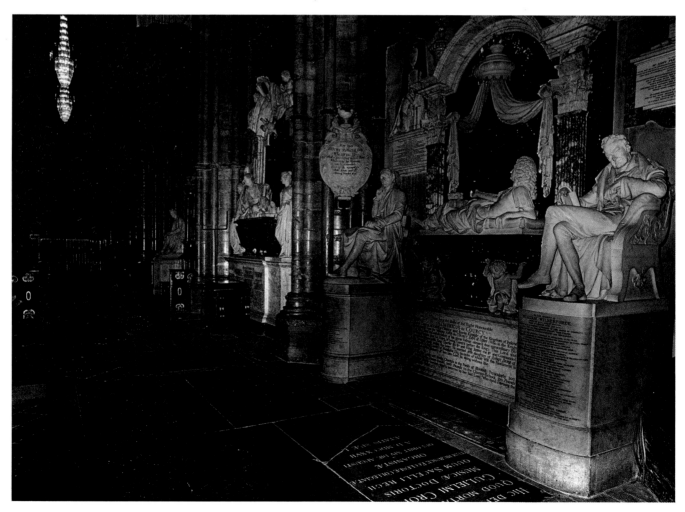

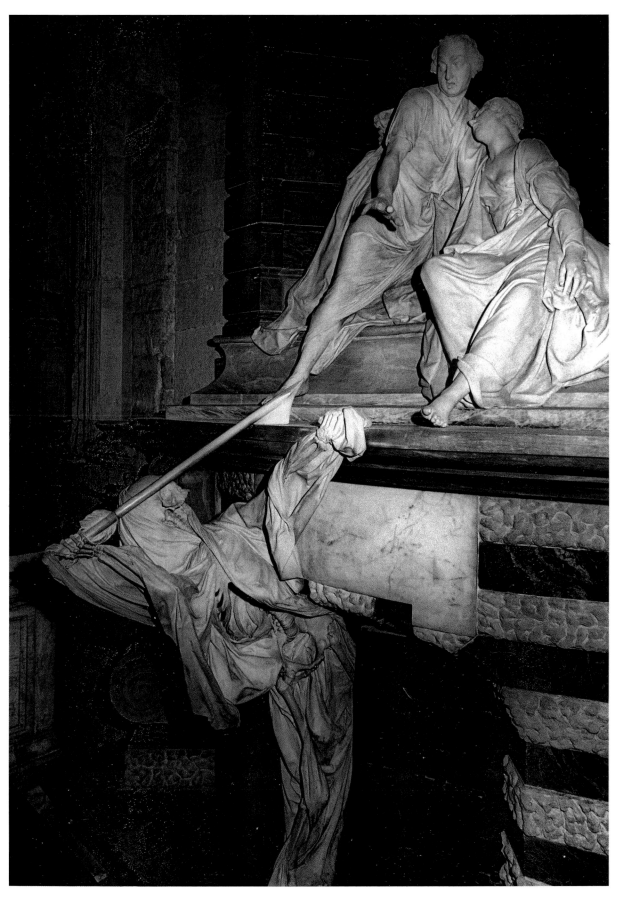

THE TOMB OF JOSEPH AND LADY ELIZABETH NIGHTINGALE,
WESTMINSTER ABBEY

Bowes Station
Durham, England

Part of the old South Durham and Lancashire Union Railway line, Bowes Station was opened on 4 July 1861 and was officially closed on 22 June 1962, but there are those who still need convincing that the old ruin has finally been laid to rest. The track ran for twenty-three miles between Barnard Castle in Durham and Kirkby Stephen in Cumbria across wild moorland and was mainly used for transporting iron ore and coal. The station itself is now one of the most haunted looking places I have ever seen and stands next to the busy A66 road. Passing motorists have reported seeing strange lights in the building late at night and of the ghostly figure of an old man standing in one of the dark glassless windows. But it is not just travellers who have had unpleasant experiences here. In 1967 two young soldiers from nearby Catterick army camp, who were keen train spotters, decided to visit the old station in their free time to see if there were still any souvenirs to be found.

It was a typically cold, wet and misty moorland day and they were a little disappointed when they saw how derelict the station had become. After half an hour one of them said that he wanted to leave, but his friend was too busy trying to look up an old chimney and didn't hear him. The first soldier walked away saying that he was going to look for a pub. His friend suddenly touched something smooth and round that was stuck behind the brickwork. He pulled it out — and screamed at the sight of a human skull staring back at him. Throwing it against the wall, he ran for his life. Whether the skull and the ghost of the old man are connected seems probable, but why it was stuck halfway up a chimney doesn't bear thinking about.

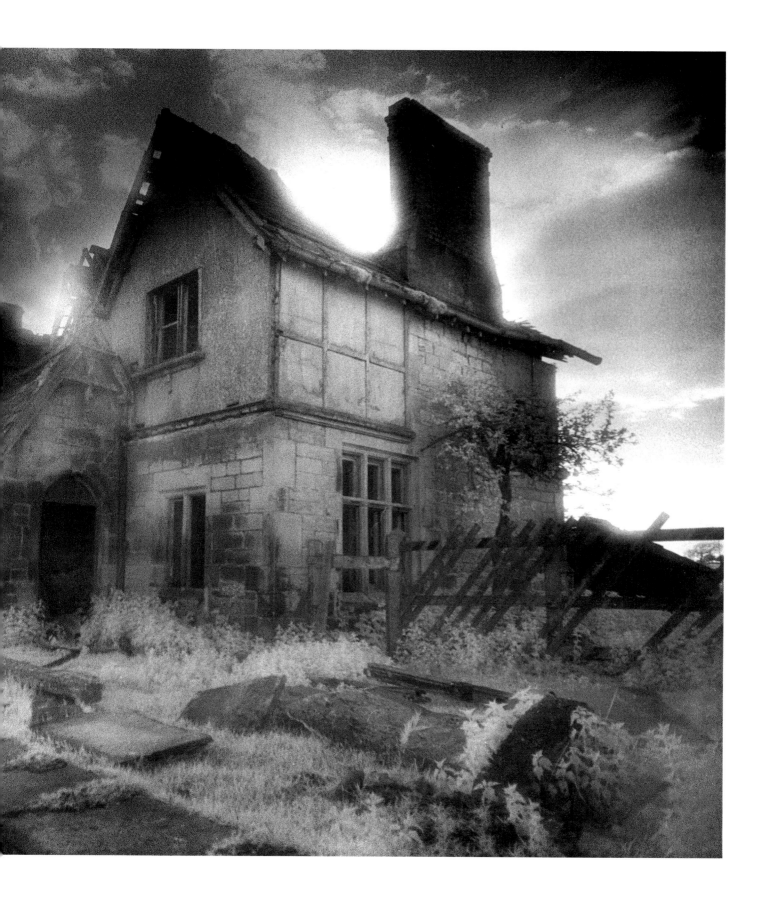

LISSADELL HOUSE
County Sligo, Southern Ireland

The darkness drops again; but now I know
That twenty centuries of stony sleep
Were vexed to nightmare by a rocking cradle,
And what rough beast, its hour come round at last,
Slouches toward Bethlehem to be born?
(The Second Coming by W B Yeats)

Amongst the many ghosts of the past that still haunt Lissadell is the spirit of William Butler Yeats, the great romantic Irish poet, who immortalized the mansion and the surrounding landscape in verse. For him the real world was the world of the occult and, as a member of the Hermetic Order of the Golden Dawn, a secret occult society, he actually practised alchemy and magic as part of his lifelong commitment to the supernatural. He believed that he belonged to an ancient Celtic tradition as old as time itself and he drew his inspiration from these rich sources of mythology and rune.

This austere looking house, which lies in a heavily wooded demesne overlooking Sligo Bay, was the family

THE DINING ROOM, LISSADELL HOUSE

home of the eminent Gore-Booth family, Elizabethan soldiers and settlers, and was built by Sir Robert Gore-Booth around 1830. Controversy surrounded several members of this distinguished family, none more so than Constance Gore-Booth, later Countess Markievicz, the Irish freedom fighter and friend of the Dublin poor, who was imprisoned and condemned to death by the British, but later reprieved. It was on Yeats's first visit to the house, when late one night he was climbing the great staircase, that he saw the ghost of a long lost friend. This experience made a profound impression upon him, confirming his undying belief in the spirit world.

It was a cold winter's afternoon when I drove slowly up the long, winding driveway towards the house, the bitter sea wind howling through the gnarled and twisted trees that overshadow the old track. The present owners are the son and daughter of Sir Josslyn Gore-Booth, a noted horticulturist, and it was the very English Eva Gore-Booth who greeted me. As this gracious and gentle woman showed me through the building I was entranced by the faded grandeur of the rooms; it was as if time itself had stood still, encapsulating the beauty and eccentricities of a lost age. Sir Henry Gore-Booth was a celebrated Arctic explorer, hence the billiard room is adorned with harpoon guns and massive whale bones and, amongst the many hanging banners, is one presented to Sir Robert in gratitude for mortgaging his estate at the time of the disastrous Potato Famine, in order that the local people might be fed. Many weathered portraits and worn stuffed animals hang eerily throughout the house, but the strangest room of all is the dining room, with its remarkable series of elongated murals by Count Casimir Markievicz, Constance's husband, depicting members of the family, together with the gamekeeper, forester and the butler.

During tea Eva Gore-Booth talked of the past, of her love of horses and especially of this old house. She told me that her family had a good relationship with the Irish people, so much so that when the local unit of the IRA had been commanded to burn down the house in the 1920s they had refused and their leaders had been compelled to summon a force from Cork in the south of the country to carry out the order. When this group of men were approaching the house, however, they had suddenly turned and fled, claiming they had seen the ghostly figure of a tall man behind every tree on the driveway. While she was telling me these stories I could occasionally hear the sad and plaintive sound of a piano being played, I presumed by her brother, who I never saw. She told me that she had never personally seen a ghost at Lissadell, but I came away with the feeling that I had been privileged to witness the phantoms of a bygone era; it had been a sad but magical experience.

WILLIAM BUTLER YEATS AS A YOUNG MAN (1865–1939)
(Hulton–Deutsch Picture Company)

THE GREAT STAIRCASE, LISSADELL HOUSE

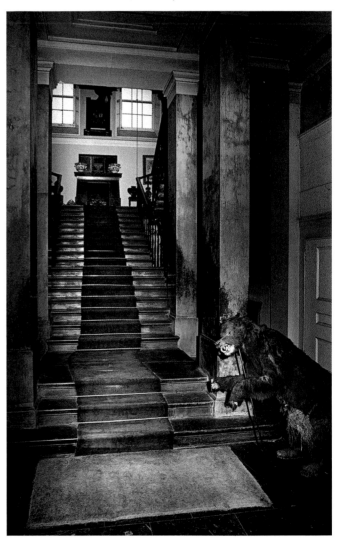

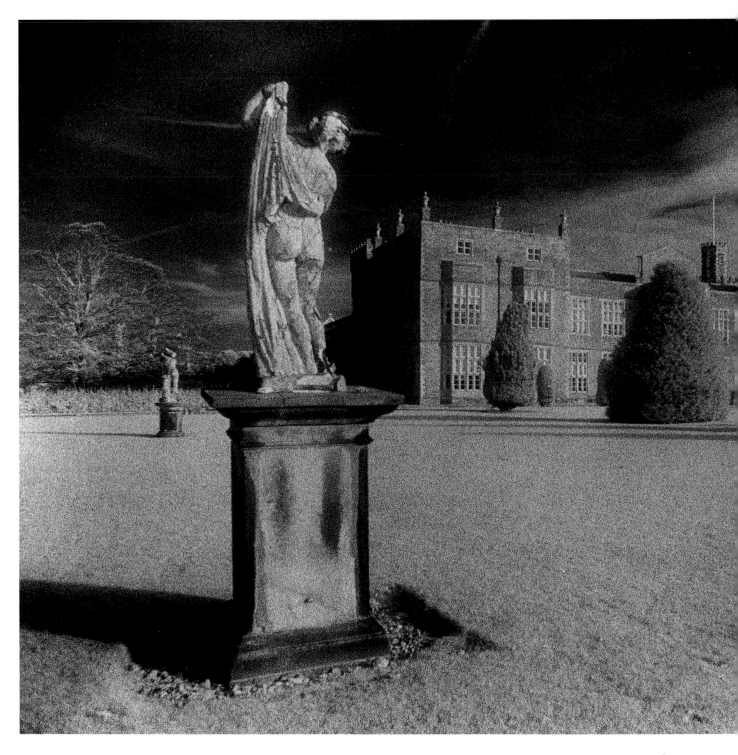

BURTON CONSTABLE HALL
Yorkshire, England

This large Elizabethan mansion, in its low-lying surroundings, could almost be mistaken for a giant doll's house. It is the seat of the Constable family and the present owner, John Chichester-Constable, has the magnificent title forty-sixth Lord Paramount of the Seigniory of Holderness. This has always been a Roman Catholic household and the family has an impressive military history.

On my arrival at the hall I was ushered down a long dark passageway to the estate office. Here I talked with David Wrench, the curator, about the extraordinary history and ghost stories attached to the house, and about how many of these apparitions have been witnessed by both the owners and the many members of staff, as I was about to discover. Mr Wrench himself had frequently sensed and heard the presence of 'something' in the house. In fact, during one dinner

recently a female employee had left suddenly because of something she had seen or heard here.

I was then taken on a tour of the house which began in the Chinese Room, where fierce and beautiful carved dragons claw at the windows and ceiling, then on through to the Grand Staircase where the fireplace in the hall is said to come from Versailles and several of the paintings are from William Beckford's fantasy creation, Fonthill Abbey. Here we met a cleaner called Jasmine who told me that she often heard the phantom footsteps, but that they never seemed to arrive where one stood. After climbing the impressive staircase we entered what is known as the 'Museum Room', which contains much of the scientific collection of William Constable, who was a Fellow of the Royal Society and died in 1791. Much of this intriguing collection was found hidden in an attic of the house, and such is the fairytale atmosphere and structure of the building that fresh discoveries of such forgotten treasures are frequently made. William Constable's ghost is said to haunt the Gold Bedroom close to the museum, and was last seen by the present owner's grandmother.

Next I was shown a beautiful room that had been decorated entirely with murals based on *Alice in Wonderland* characters designed by W.A. Sillince, the *Punch* magazine cartoonist, but was then told that another kind of fantasy world existed below the floors, a labyrinth of secret passages that were once peopled by the fleeting shadows of priests, monks and nuns who had taken refuge in the Catholic stronghold. The ghost of a nun is said to glide down the impressive Long Gallery.

Returning downstairs I saw the silhouette picture of Nurse Dowdall, who served as a nanny at the house during the nineteenth century. She was much loved by the family and hers is the ghost most frequently seen in the house. In the kitchens, where there is reputed to be a bellrope marked Haunted Room, I met Nina, a Filipino cook who has been in service at the hall for nineteen years. The kitchens are in the north wing of the house, close to the private chapel, and she told me how she had heard a mysterious woman crying in the chapel recently, during both the day and night. She also often sees what appears to be the figure of a man in the passageway which leads into the Chinese Room, but when she follows him there is never anyone there.

Outside, the grounds have their ghosts too. The house and grounds are built on the site of a medieval village, but little remains to be seen of this settlement

party he had felt this something following him down a passageway known as the 'Print Corridor'. He was very frightened; witnesses said that he had turned pink and had deep imprints on his hands where his nails had dug in. He said that the next morning a workman's dog would not go down this passage and will never go into the ballroom next door. He said that footsteps or 'something' are said to come through the owner's front door, the oldest part of the house, then along the passageway I had just come down and stop outside this office. They have been heard by many people, and

now, while the west side of the house is surrounded by many romantic classical statues that seem as if they are part of some magnificent phantom ballet. The road that runs along the top of the drive, and which passes through the nearby woods, is reputedly haunted by a Roman legion and this vision was apparently seen recently by a teenage boy on a motorcycle, his hair was said literally to have been standing on end when he returned home.

As I drove away I was struck by the almost calm, and certainly very English way, that almost everyone that I had met had accepted the ghostly inhabitants of the house as if they were a normal part of life on the estate. At the same time, I had felt an aura of loneliness and sadness about the unique house, as if it were in mourning for the past, but then it has often been said that it is not the place that is lonely or sad, but the person who observes it to be so.

THE PRIVATE CHAPEL, BURTON CONSTABLE HALL

CLASSICAL STATUE, THE GARDENS, BURTON CONSTABLE HALL

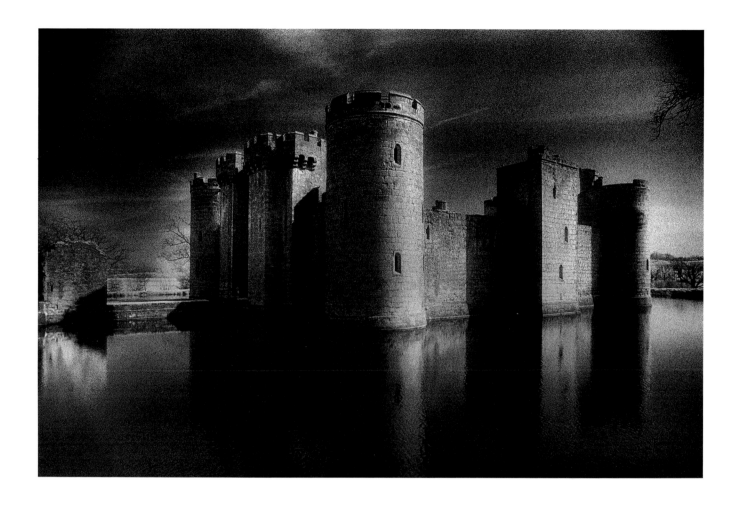

BODIAM CASTLE
Sussex, England

However many evil deeds and dastardly plots were carried out within the walls of this fairytale castle, it is now as peaceful as the tomb, its ghostly image in the deep waters of the moat reflecting past eras of grandeur and mystery. This tranquillity is said to be broken at times by the gentle sounds of spectral music from another age, and the phantom of a lady in red has been seen on moonlit nights watching from one of the magnificent towers, but who she is and who she waits for, nobody knows.

The castle was built by Sir Edward Dalyngrigge in 1386 and is a fine example of medieval military architecture. It was empty from the middle of the seventeenth century until the ivy-clad ruins were purchased by Lord Curzon in 1916, who lovingly set about restoring them.

As evening drew in and the shadows began to lengthen, I sat and watched over this bewitching scene and it struck me how the magic and inspiration of this lost world so contrasted with the heavy materialism and the drab actuality of our present-day existence.

BALLAGHMORE CASTLE
County Laois, Southern Ireland

I first heard of Ballaghmore Castle and its shadowy history from an artist friend in Dublin who had been inspired to paint it some twenty years ago. Built in the fifteenth century by the Fitzpatricks, Lords of Upper Ossory, it was strategically placed beside one of the great roads of Ancient Ireland, which passes through the wild unconquerable Slieve Bloom Mountains. Today, the once great Tower is surrounded by a farmstead and is used to store grain. But the ghostly ruin, framed by gnarled tree branches, grips the imagination as if one were under a supernatural spell. The present owner, Mrs Evelyn Clarke, whose family have lived here for forty-five years, told me something of the castle's turbulent history.

Because of its strategic position it had endured many lengthy and violent sieges through the centuries until it was finally partially destroyed by Cromwell's invading forces in 1647. The dead from the defeated garrison were buried in a large circular grave near the castle, surrounded by trees. Nothing would ever grow on this mound and it remains a sad and pathetic sight today. After this devastation the castle and lands were given to the Coote family, later Earls of Mountrath, as a reward for their military service and remained in their possession until the middle of the nineteenth century, when they sold the estate to the Ely family, who gradually began to restore the building.

As we walked around the castle Mrs Clarke suddenly pointed to a spot high up on one of the castle walls where she said one could see an ancient carved figure, known as a *sheila-na-gig*, a pagan fertility symbol said to possess supernatural powers and to have been used in secret rituals of long ago. It is now partially covered by creeping ivy.

Returning to the farmhouse, Mrs Clarke showed me some old papers concerning the castle and then pointed out a dark stain on one of the flagstones of the kitchen floor. That, she said, was the blood of Richard Ely who was shot and bled to death at Ballaghmore. His murderer was a notorious poacher called James Delaney, who afterwards fled to the mountains where legend says that he lived and died in a cave. It is also said that Richard Ely's ghost has long been reported in the vicinity of the house and castle.

I asked Mrs Clarke whether she was afraid to stay here alone at night. She looked at me sadly and said that since her husband had died she was, but not so much of any ghost that she might see, more of the living – modern-day man and, in her own words, 'his dishonesty and violence'. The castle and farm were for sale.

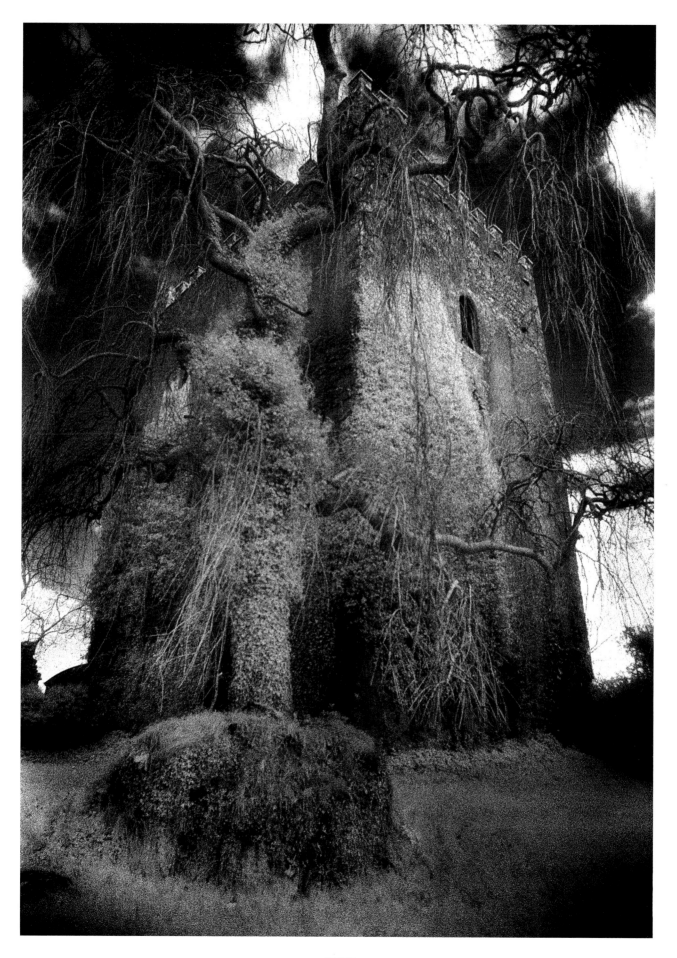

CASTLEBORO HOUSE
County Wexford, Southern Ireland

This magnificent classical mansion was built around 1840 by the first Lord Carew. His family were of English origin and had enhanced their fortunes by various astute marriages and distinguished careers in politics and the law. In 1816 Lord Carew married Jane Catherine Cliffe, who lived to be one hundred and two years old and is said to have survived three of their four children, and it is this extraordinary lady who is the focus of the following strange and supernatural story.

Lady Carew loved Ireland and this house, taking great interest in the decoration of the interiors and being particularly talented at embroidery. However, her husband's political duties meant that he spent long periods away, mainly in England. One hot summer's evening in 1856 she retired to bed early after an exhausting day and fell into a deep sleep. At around one o'clock in the morning her maid, who slept in an adjacent room, heard an horrific scream. She ran to her mistress's bedroom where she found her in a state of great distress, staring fixedly out of the window. The maid could see nothing unusual but when Lady Carew regained her composure she described in detail how she had woken suddenly, freezing cold, and when she had gone to close the window had seen the terrifying vision of a 'Phantom Funeral' in the moonlight. The odd thing was that the coffin was lying open but didn't contain a corpse, as if the mourners were waiting for someone to die. Two days later she received news of her husband's death: it had occurred at exactly the time she saw the apparition.

The family lived on at the house, although it was by now used only for a few months in a year for lavish entertaining, until it was tragically burn to the ground by the Irish Republican Army during a ball in 1923. Today it is a dark, empty shell, the crumbling steps still peopled by the spirits of so many distinguished guests. The Carew family motto is: *Nil Admirari,* to be surprised at nothing.

'THE PHANTOM FUNERAL'
(Mary Evans Picture Library)

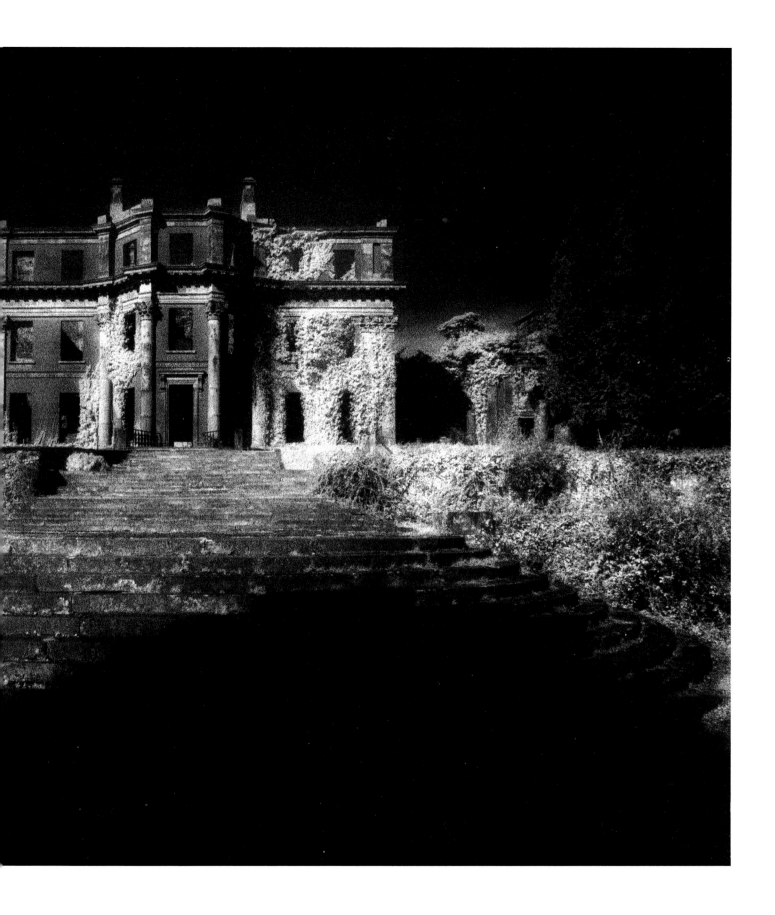

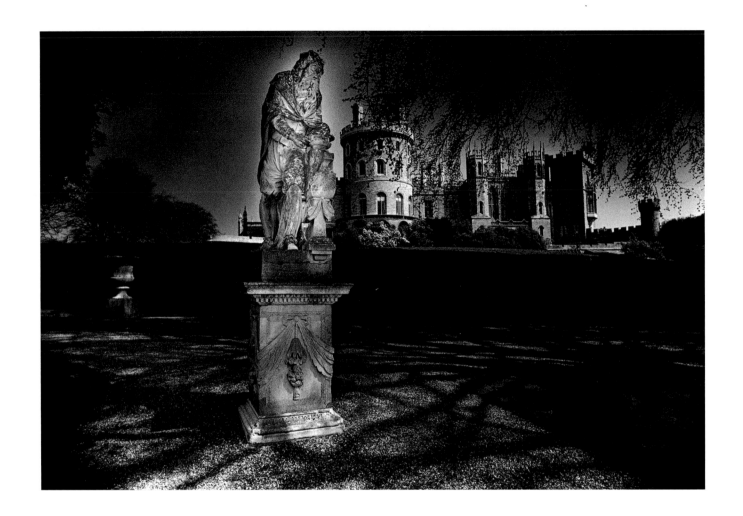

THE WITCHES OF
BELVOIR CASTLE
Leicestershire, England

Among the many servants employed at Belvoir Castle by the sixth Earl of Rutland during the seventeenth century was a certain Joan Flower from the nearby village of Bottesford, and her two provocative daughters, Margaret and Phillipa. Joan was unpopular with her neighbours; she was uncouth, malicious and, worst of all to these God-fearing peasants, an atheist. Her appearance was wild and unkempt and she boasted of the strange powers that she possessed. In short they suspected her of being a witch.

Over a period of time the Countess herself became suspicious of the shameless and degenerate behaviour of all three and when she discovered Margaret stealing from the Castle, she seized upon the opportunity to dismiss the wench. Joan, enraged by the Countess's action, began to plan her revenge. The three, together with others, summoned the help of the Devil and began casting evil spells on the Earl and his family. Within a year the Earl's two infant sons had died and later the Earl and Countess themselves suffered terrible con-vulsions and sickness before eventually becoming sterile.

Several years later Joan, her two daughters, and three other women were arrested and tried in Lincoln. The coven of witches admitted many other appalling crimes to the court, but then Joan Flower recanted and denied murdering the two boys. At this point she called for bread and butter to prove her innocence. She said that 'she wished it would never go through her if she were guilty': this was the old 'test of ordeal' used in Anglo-Saxon times. Her wish was granted, for she choked to death there in the courtroom, confirming herself as a witch. The others were also found guilty and were hanged at Lincoln on 11 March 1618.

I visited the church at Bottesford where you can see the so-called 'Witchcraft Tomb'. Kneeling at the feet of their parents are the effigies of the two unfortunate boys, both holding skulls as symbols of death. The inscription states that: 'they dyed in their infancy by wicked practise and sorcerye'.

WITCHES SABBATH
(Hulton–Deutsch Picture Company)

DUNTULM CASTLE
Isle of Skye, Scotland

The spectral ruins of Duntulm Castle are perched high up on a prominent rock face in the far north-west corner of the legendary and magical Isle of Skye. This virtually impregnable castle was built on the site of an ancient fort, Dun Dabhaid, the residence of the norse princess, Biornal.

A principal seat of the MacDonalds, Lords of the Isles, the castle had a particularly violent history until the clan was forced to abandon it around 1730 because, as legend says, they could no longer live with so many tragic and horrific ghosts that endlessly roamed the once great halls. The most awesome phantom is that of Donald Gorm Mór, the legendary MacDonald chieftain, a ruthless and feared warrior, who eventually bled to death in the castle, having been mortally wounded by an arrow. One of his sons, an infant of only eighteen months, is said to have accidentally fallen out of the arms of his nurse from the castle walls and been dashed to death on the cruel rocks below. The old woman was hurled down after him and her pathetic apparition is still seen by the edge of the cliff.

But by far the most horrific legend, which has several versions, tells of the imprisonment and death of a cousin of Donald Gorm, Uisdean Mór. They were rivals for not only the leadership of the clan but for the love of the same woman. Eventually the cunning of Donald Gorm triumphed and, having captured his cousin by trickery, he had him thrown into the deepest and dampest dungeon in the castle with only a piece of salt beef, a loaf of bread and a jug of water. When the young man could control his hunger no longer he first devoured the salt beef and then the bread. Overtaken by an uncontrollable thirst he then began to raise the jug to his lips, but to his horror it was empty, his cousin's last perverted and evil act. He died insane, his agonized screams piercing the thick walls of the castle, as they are still said to do long after his death.

The dark dungeon vaults have long since been filled in with stones, but one can still see the hollows that were hewn into the rock face below the castle where the MacDonalds secured their majestic galleys and, as the icy cold winds shriek and howl through the remaining stones of the castle walls, these eerie tales of the past seem all too real.

ELTON HALL
Cambridgeshire, England

The eccentricities of some members of the Proby family, Earls of Carysfort, who had strong Irish connections, are accurately portrayed in the very different styles of architecture that make up this romantic and rambling house where the family have lived for over three centuries. The administrator of the estate, who showed me around the property, explained how a house had originally been built here by the Sapcote family in the fifteenth century, but only the chapel and the gatehouse tower remain, now incorporated in the new house built by Sir Thomas Proby when he purchased the freehold of the lands in the seventeenth century.

She said that over the years the house had sometimes been divided up between various members of the family so that they could lead separate lives, isolated from one another, and that towards the end of the nineteenth century either a cousin or brother of the fourth Earl of Carysfort, she couldn't remember which, had lived alone in the old gatehouse tower. This man was a compulsive gambler who frequently suffered heavy losses at cards but he devised a cunning plan to overcome his massive debts. He would lure unsuspecting fellow gamblers to the estate and then, if he lost to them, would offer to take them on a tour of the park where he would hit them over the head from behind and leave them unconscious, whilst relieving them of the money they had won from him. On returning to the house he would send out his servants to look for them so that the poor victim felt that he was being helped rather than mugged. Unfortunately, events sometimes went too far and the luckless man would be killed by the blow, at which point the servants would throw his body down a well in the garden.

WINDOW OF THE OLD GATE HOUSE TOWER, ELTON HALL

It is said that the ghost of this evil man is seen wandering the park at night, no doubt searching for new victims rather than in repentance for his horrific crimes. Several people, including a maid and a recent manager of the estate, have seen the ghost, dressed in a long black cloak, within the last five years.

While I was photographing the exterior of this fascinating house I suddenly noticed the head and shoulders of an old man staring out of a window in the old gatehouse tower below the ancient Sapcote coat-of-arms. After my initial shock I realized that it must be the bust or statue of some distant relative, but it was getting late and there was no one left to ask. As I walked back to my car, past the semi-derelict stable block, I took great satisfaction in the thought that the so-called 'march of progress' had for the time being passed this unique location by.

[111]

LEAP CASTLE
County Offaly, Southern Ireland

Known universally as the most haunted castle in all Ireland, Leap Castle is without a shadow of doubt the most sinister and frightening building I have ever photographed. Once the principal seat of the powerful and warlike O'Carrolls, Princes of Ely, it stands on a vast, ancient rock guarding a strategic pass through the wild Slieve Bloom mountains. My first visit was for a book that I was compiling called *In Ruins – The Once Great Houses of Ireland*, and I can distinctly remember my initial feelings of fear and fascination; nowhere before had ever held so many suggestions of the supernatural.

The O'Carrolls were the last sept to surrender to the British in the seventeenth century and their fearsome reputation has left behind a legacy of intrigue and murder as brother fought brother for control of their empire. Local people are still in awe of the castle and are fearful of the many ghosts that are still said to haunt this ruin. Above the main hall of the great fourteenth-century tower is what is known as the 'Bloody Chapel' where 'one-eyed' Teige O'Carroll slew his brother at the altar and, late at night, passers-by on the main road have seen a window of the room suddenly illuminated by a strange light. In one corner of this chamber was a spiked oubliette, a secret dungeon into which unsuspecting prisoners were thrown down through a trap door and conveniently forgotten. It is said that three cartloads of bones were extracted from here after the house was destroyed by fire in 1922. Below the keep, it's said, stretches a network of deep dungeons hewn into the rock, containing bricked-up passages and secret chambers. Several human skeletons and spearheads were found here too. It is interesting to note that the last owners of the house before the fire, who added the Gothic wings, were said to have been unaware of the existence of these cavernous tombs.

During the period of the Darby's residence overnight guests frequently experienced the terrifying spectre of a tall female figure, dressed in what seemed to be a red gown, with her right hand raised menacingly above her head, seemingly illumined from within. The unfortunate visitor always awoke suddenly in the middle of the night, prior to this nightmarish vision, with an extraordinary and violent cold feeling in the region of their heart. Whether this ghost is connected with the murder of a princess of the royal O'Carroll

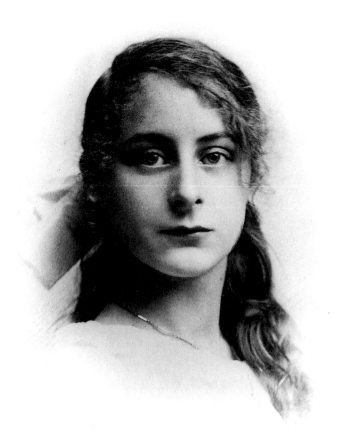

LOUISE ASHBY, PETER GERRARD'S MOTHER

PETER GERRARD

household many centuries ago is not known, but this State Bedroom was always shunned by the Darby's servants. The strangest and most demonic spectre in the castle is a foul smelling elemental, half-human, half-beast, that haunts the tower stair and is believed to be the embodiment of all the horrific and evil deeds that have taken place here.

The Darby family obtained the estate when Jonathan Darby married the daughter of an O'Carroll chieftain in the seventeenth century. A staunch Royalist, he was known as the 'Wild Captain', and legend says that he hid a fabulous hoard of treasure in the castle with the help of two servants, who he then murdered, before being imprisoned for treason. When he was released many years later his mind was so deranged that he couldn't remember where he had hidden the hoard, and the mystery remains to the present day.

Lord Rosse, who lives at nearby Birr Castle, built by his ancestors on the site of another former O'Carroll stronghold, told me that he had always been, and still is, frightened by Leap. He said that his father had told him that as a child he would sometimes go to tea there with his governess and that, because of persistent rumours of several skeletons being bricked up behind the wall in one room, the then Lord Darby became enraged by what he considered to be idle gossip and had the wall dismantled, where, to his horror, three upright skeletons were found. He immediately had them bricked up again, saying that if one of his ancestors had killed them then it must have been for a good reason. Lady Rosse, an eminent archaeologist, believes that the castle is situated on a ley line and that the powerful forces these ancient alignments generate can be influenced by both good and evil, unfortunately in this case the latter. She added that she had been present at a recent exorcism attempt by a Mexican medium at the castle, but had found the experience unnerving.

I then visited Peter and Mide Gerrard who had owned the castle from 1973 to 1975. They told me that, after being burnt in 1922 by the IRA while the Darbys were living in England, a mob had ransacked the mansion and macabrely hung the tame peacocks from meat hooks on the tower. The Darbys then gave the castle to an old lady, a family retainer, who later died of a gangrenous leg. After it changed hands once more they had purchased it as an investment. Peter Gerrard told me his mother had been a friend of Cicely O'Carroll-Darby, and she had been invited to spend a night at the castle for a dance. She told him afterwards that she hadn't slept well and continually felt that someone or something was hovering over the end of her bed. He added that he thought the whole area around Leap was evil and that nothing good had befallen anyone who had owned it. He then said that he hoped he had escaped this curse because he had lost money when he sold it – we all laughed nervously.

The next owner, Peter Bartlett, was an Australian

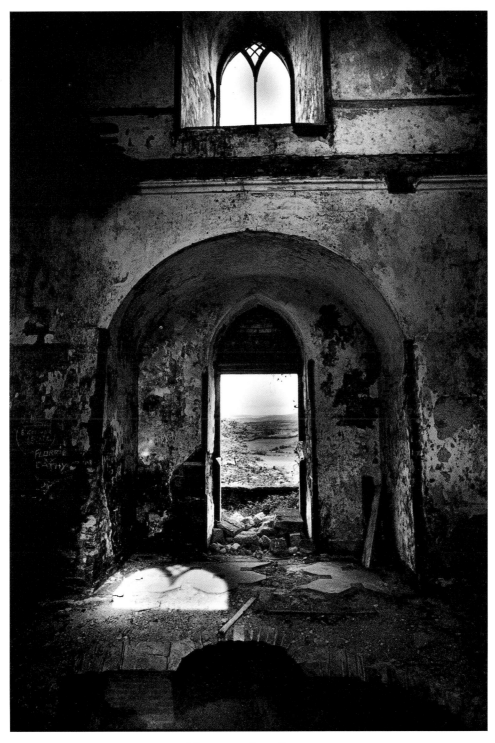

MAIN HALL, LEAP CASTLE

and an O'Bannon. His clan had held the castle before the O'Carrolls, but were secondary chieftains to them. I had dinner with him one night in the summer of 1988 and noticed that his tenancy at the castle was exerting both a mental and physical drain on his resources. He told me that many extraordinary poltergeist phenomena had taken place when he began to renovate the building and he was inclined to support Lady Rosse's theory of the overwhelming powers of the rock. He believed that we are living in an age when the ghosts of all the dead and departed are crying out to warn us not to abuse nature and its abundance. Peter died tragically the following year and the castle is now in the hands of a trust. Lady Rosse told me that she was keen to rid the castle of its ghostly reputation, but I wonder what powerful magic can cleanse this dark fortress of its fiendish past: to me, these supernatural powers are best left alone.

[115]

CLEOPATRA'S NEEDLE
Victoria Embankment, London

The death curse of Cleopatra, the legendary Egyptian Queen, has been associated with this giant obelisk since her dramatic suicide in 30 BC. The monument, which now stands beside the River Thames, is over sixty feet high and is guarded on either side by two sphinxes. It is a symbol of the magic, mystery and superstition of one of the world's oldest civilizations.

Originally sculpted over 3000 years ago during the reign of Tahutmes III, the column was offered as a gift to several British monarchs by the Egyptian government, but each politely refused until the offer was finally accepted in 1877. However the voyage nearly ended prematurely in disaster when six seamen were drowned in a ferocious storm off the Bay of Biscay. It finally arrived safely in England the following year and was erected where it stands today, but the ancient curse still appears to prevail.

According to London's River Police there are more suicides and attempted suicides in the vicinity of the obelisk than on any other stretch of the Thames and the sounds of maniacal laughter and pathetic moans are frequently heard here. The hazy outline of a naked man has also been seen jumping off the wall, but there is never any sound when his body hits the waters below.

I photographed the pillar early one winter's morning when the area was deserted except for an old tramp who was sleeping on the steps below the monument. This juxtaposition of grandeur and poverty, a reminder of the enigmatic and fragile nature of man's existence, somehow contrived to make the legend of the ancient curse more frightening.

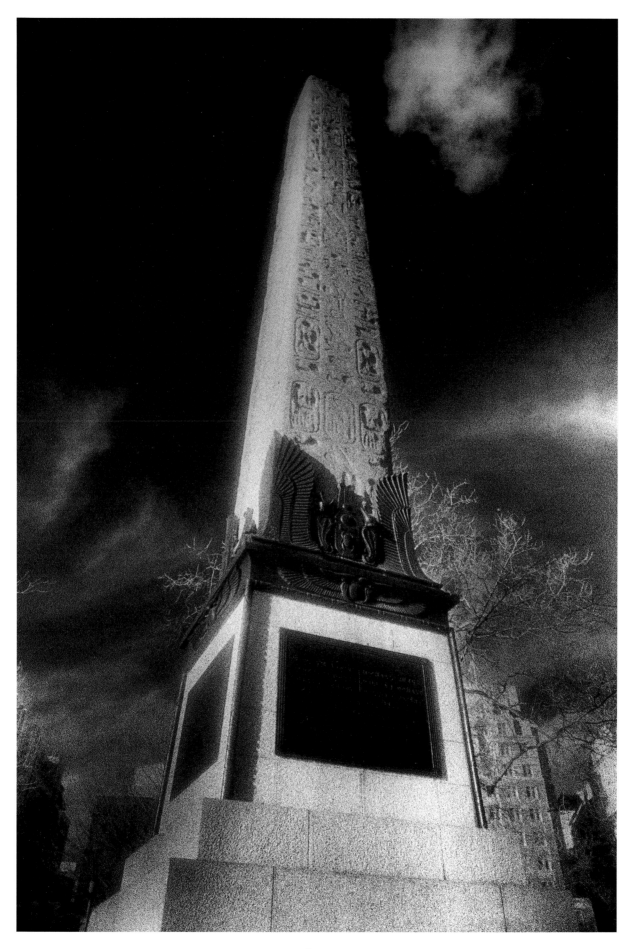

NEWARK PARK
Gloucestershire, England

Often referred to as a 'house of mystery' the setting of Newark Park, high up on an escarpment in the Cotswold Hills surrounded by forests and ancient deerparks, is so remote that one can feel lost in a forgotten world. My first sight of the forbidding building was unnerving – the harsh winter mist seemed to be creeping up over the grey windows as if to hide whatever dark secrets lay inside. As I parked my car in front of the house, the doors suddenly burst open and three of the largest Great Danes I have ever seen surrounded the car as I remained frozen in my seat. They were followed by their owner, Bob Parsons, an architect who originates from Texas and rents the house

[118]

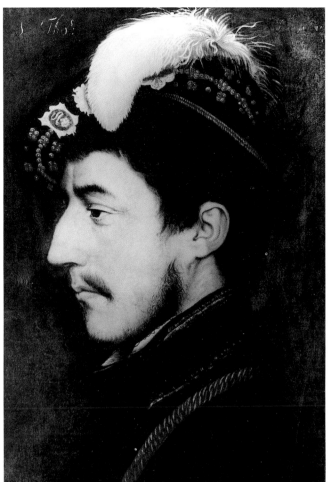

Henry VIII in 1539, to two years spent in a debtor's prison from 1541–3; then in 1546, he was made Vice Admiral of the Fleet in the wars against France and Scotland. Bob Parsons added that a chronicler of the time, Aubrey, noted that he was a womanizer and on the completion of Newark Park remarked that 'Sir Nicholas Poyntz has built a fine new house to keep his whores in'.

The house then changed hands several times before being remodelled in 1790 for the Reverend Lewis Clutterbuck and remained within his family until 1949, when it was bequeathed to the National Trust in memory of one of the sons killed in World War I. The Trust in turn rented it out as an old people's home, but the company ran into financial difficulties and the house quickly deteriorated. It was then left empty for a number of years until Bob Parsons decided to take over and begin the mammoth task of rediscovering and restoring the house and grounds, which is still continuing today.

At a dinner party shortly after Bob moved into the house, a neighbour asked him if he was aware that the

from the National Trust. He dragged the dogs away and asked if I would like some lunch.

I followed him into the kitchen where I met his caretaker Michael Clayton, a former opera singer with a passion for old houses, who told me that there was very little written history of this house but that it had originally been built in 1550 by Sir Nicholas Poyntz of nearby Iron Acton as a hunting lodge. Sir Nicholas had a varied career from Groom of the Bedchamber to

house was haunted. He replied that he wasn't, so she told him that he could read about it in an old book in the house library. Unfortunately, however, all these books had been sold several years before. Bob has had many supernatural experiences over the years, continually hearing ghostly footsteps and loud crashes in the middle of the night for no apparent reason, old servants' bells which mysteriously ring of their own accord and, most frightening of all, great pressure being exerted on his bed in the middle of the night, but he has never actually seen a ghost here, only felt their presence. He said that most people who stay at the house experience similar phenomena.

Michael Clayton then offered to show me around the house and grounds. We started by descending an endless flight of stone steps into the vast old cellars, which contain exhibits of strange miniature figures, ancient coins and other artefacts that have been unearthed in the beautiful but overgrown grounds. Michael said that many secrets had been discovered in the house too, including a hiding place under the floorboards in one of the bedrooms. The damp, cold cellars were particularly unsettling and I couldn't help but think of the old people who had come to die in this lonely house.

As we toured the rest of the building I admired the effort that clearly must have gone into the restoration and sensitive furnishing of the rooms, but all the time I felt that the house itself had an underlying feeling or presence of evil, of dreadful secrets still hidden within its walls. I was left alone to take photographs and later returned to the kitchen for tea, where I asked my hosts more about their strange experiences. Bob Parsons told me how several members of the 'Ghost Club' had spent a night here some time ago and had recorded strange voices, footsteps and rattling chains. On another occasion a television company had used the house to make a Gothic film called *Zastrozzi*, originally by Shelley; when the set painter was upstairs working in the house he heard footsteps and thought it was Bob, but discovered later that he had been alone in the house. Michael added that one of the bedrooms was particularly haunted and that only recently a visiting psychic had come out in strange red blotches outside this room – she had not been told about its reputation in advance.

It was now dark and time to leave. I shook hands with my generous hosts, and could not resist asking them why they stayed in such a house. Bob Parsons replied that he wasn't really sure, but had simply felt drawn towards it from the beginning. As I walked out through the hall I noticed the macabre sheep's skull frieze high up on the ceiling, and I couldn't help wondering how many other skeletons were yet to be discovered in this strange old house.

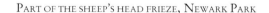

PART OF THE SHEEP'S HEAD FRIEZE, NEWARK PARK

LES TROIS MAGOTS BY JAMES GILLRAY
(reproduced by Courtesy of the Trustees of the British Museum)

CASTLELYONS
County Cork, Southern Ireland

The Barrymores are remembered as, if not the most powerful, then certainly the most infamous aristocratic family in all Ireland. They were of Anglo-Norman ancestry and at the height of their powers ruled over more than 300,000 acres in County Cork from their principal seat at Castlelyons. The castle stands today as a sensational ruin, the many tall, ivy-clad chimneys, a principal landmark for miles around, a sad and poignant memorial to the family's ignoble record of treachery, murder and debauchery that finally decimated and bankrupted their tyrannical rule.

Only a single massive wall remains of the original castle, which was built on the site of a previous fortification of the Irish clan, the O'Lehans, and the Barrymores' awesome reputation was already well established by the time that David Barry, who was to be created the first Earl of Barrymore in 1627, inherited the estate from a great uncle who was deaf and dumb. He quickly set about building a magnificent mansion befitting a man of his rank, which was described as containing a great, spacious hall, hung with many weapons and the heads of great animals killed in the chase. There was also a noble gallery, vast stables, famous gardens and a great deerpark. The first earl was to prove himself to be as fearsome as his ancestors, but worse was to follow.

The second and third earls were involved in serious political intrigues and the fourth earl, who had strong Jacobite sympathies, was arrested for treason in 1744, having been betrayed by his own son and heir who became the fifth earl. This opportunist had a weakness for drink and was described as literally throwing money away, and it was he who began the family's rapid descent into bankruptcy. The sixth earl, Richard Barry,

[121]

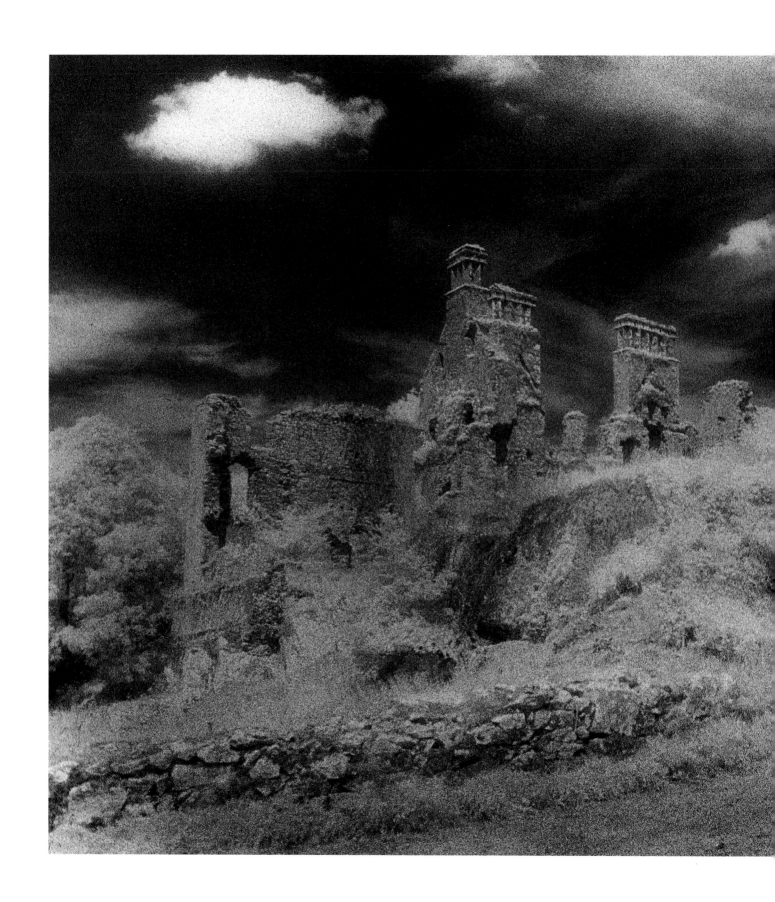

succeeded to the title in 1751 when only six years old and was said to have been a gambler and a cheat who died when only twenty-eight years of age. Educated in England at Eton and Oxford, he spent most of his time abroad and was an absentee landlord of the worst kind. It was during his time that the castle was destroyed by a tragic fire in 1771.

The earl's children, orphaned at a young age, were brought up in England where they were grossly spoilt by their guardians. Richard, the eldest, who was to become the seventh earl, inherited the family's fortune and was said to have been given £1,000 for pocket money while still at school. Together with his brothers, Henry and Augustus, he became close friends with the then Prince of Wales, later George IV, who dubbed these three outrageous and wild characters with suitable nicknames: Richard was Hellgate, Henry, who had a club foot, was Cripplegate, and Augustus was Newgate. Their sister Caroline was known as Billingsgate, after the famous London fish market, because of her notoriously foul language. The celebrated satirical caricaturist of the time, James Gillray, immortalized the three brothers as 'Les Trois Magots', and society was both shocked and appalled by their outrageous behaviour. Richard, who was said to have been endowed with genius, learning and wit, had pretensions to be an actor but managed to squander £300,000 before his accidental death in a shooting accident at the age of twenty-four. Henry, the eighth and last earl, died of a fit in France in 1823.

The castle itself is haunted by the pathetic, pleading ghost of a young man who fell foul of the sadistic sense of humour of one of the earls. It is said that one of the estate workers had a chance meeting with the earl one day when he asked her about the welfare of her children. She told him that she was worried about one of her sons, who had fallen in with the wrong company and stayed out until the early hours of the morning. The earl said that she should send him up to the castle that night and he would talk to him. This the woman did, but as midnight struck the boy had not returned so, thinking that he had disobeyed her and gone to see his friends as usual, she set out for the big house where she was assured by a servant that her son had arrived long ago. The then earl appeared, saying that she would have no more trouble with the boy and inviting her to follow him out to the stables, where to her horror the boy was hanging dead. She cursed the earl, prophesying that a great fire would destroy the castle and the family fortune. The widow's curse fell in 1771.

The fire started when two itinerant tinkers, Andy

Hickey and his apprentice Lewis, were repairing some lead gutters on the roof. They had been called down for lunch and some beer when, in their haste, they left a red hot soldering iron on some woodwork. By the time they returned the roof was on fire; they could have put it out, but instead fled in fear of their lives. A crowd of villagers on seeing the flames ran to the building to help, but the English housekeeper, unaware of the fire, refused to let them in, thinking they were intending to exact revenge on their hated landlords. The fire is said to have smouldered for three months. According to James Healy in his *The Castles of County Cork* no trace of Hickey was ever found, but Lewis settled down in Templeruane as a wigmaker near the graveyard, using a skull as a model. He lived to be one hundred and seventeen.

I was shown the Barrymore mausoleum in the gloomy Gothic graveyard in the village of Castlelyons. Above ground is the impressive memorial to the fourth earl, but down below the iron gate has been forced open to reveal the smashed coffins of other family members, their skeletons scattered over the stone floor. It struck me that this gruesome violation of the dead had been carried out in a spirit of revenge rather than in expectation of discovering hidden jewellery or other valuables. It was a frightening and bizarre twist to an almost lunatic tale.

REMAINING WALL OF THE 'OLD' CASTLE, CASTLELYONS

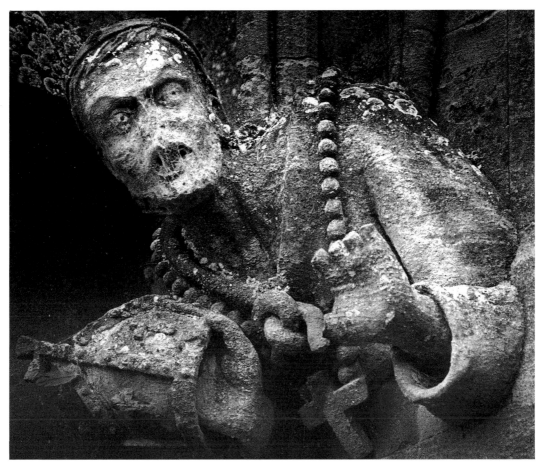

SCULPTURE OF BECKET'S MURDER, TODDINGTON MANOR

TODDINGTON MANOR
Gloucestershire, England

Thomas à Becket was cruelly murdered in Canterbury Cathedral in 1170 by four knights, acting upon the idle threats of Henry II. One of these knights was William de Tracy, whose own pedigree could be traced back to Charlemagne. There has always been controversy over which line of the noble family he was descended from; some say the Devon Tracys – and there are many legends of his ghost performing endless acts of repentence in that county – but others say the Gloucestershire Tracys, who owned estates at Sudeley and Toddington. In his informative book, *The Sudeleys – Lords of Toddington,* the present Lord Sudeley leans towards the latter theory, and as one approaches Toddington Manor today one can almost sense the guilt of the ghosts of the past within the mysterious walls of this now deserted masterpiece of ecclesiastical Gothic architecture.

Built by Charles Hanbury, the first Lord Sudeley, in 1820 it replaced an earlier mansion of the Tracys, who had lived here for almost one thousand years of uninterrupted succession. He had no doubt of his family's guilt, even commissioning statues of the murder to be placed above the main doors, and he covered the rest of this fantastic building with horrifying figures and grotesque gargoyles, many now fiendishly staring from beneath intricate spiders' webs. This house of horror is said to be full of secret passages below eerie halls and magnificent stained glass windows. The fourth earl was bankrupted and forced to sell the estate in 1901, and it then changed hands several times before becoming an exclusive school for Arab children until its eventual closure in 1985.

A local story tells of the nightmarish figure of a man, half flesh and half skeleton, which is said one night to have terrified two robbers who ran screaming from the grounds – interestingly, legend says that Sir William Tracy died of leprosy during a crusade of repentance in the Holy Land and tore the rotting flesh from his own bones. Having obtained permission to photograph the outside of the building from the warden I found that I did not want to stay too long: this is a monument to a haunted lineage and a unique memorial to the Gothic genre.

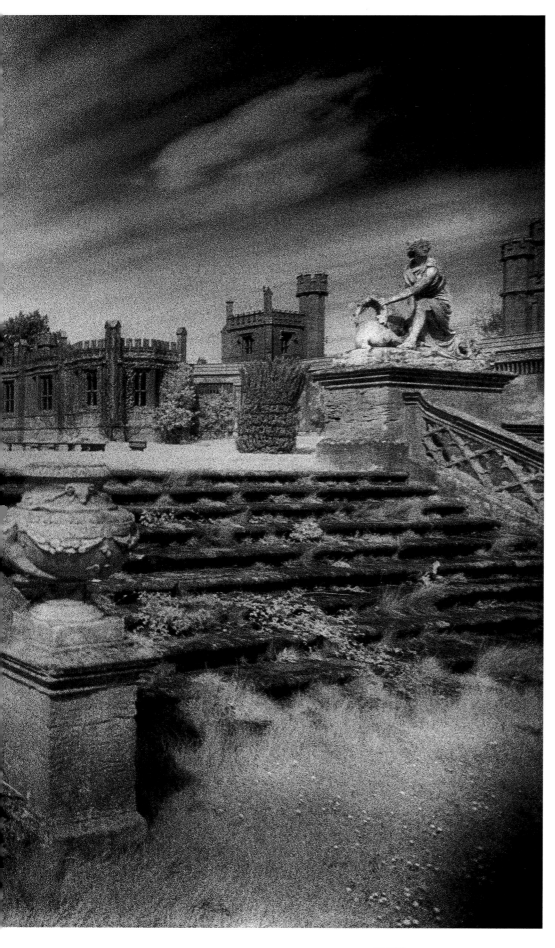

ACKNOWLEDGEMENTS

I should like to thank the following for their help and inspiration: Elizabeth Hickey, Joshua Freiwald, Michael and Eileen Casey, Jessica Berens, Emma Foale, Lachie and Nicky Rattray, Peter and Mide Gerrard, John Colclough, Brendan and Alison Rosse, Cornelia Bayley, Bob Parsons, Michael Clayton, Eva Gore-Booth, Sandra Colclough, Mrs Evelyn Clarke, David Wrench, Stephanie Sutton, Peter Bartlett, Christine Strang, Roger Farnworth, Richard and Brian Adams, Mr and Mrs Charles Kerton, Gilbert and Eva Webb, Frances Watkins, Jan Becket, Mr and Mrs Anthony Emerson, Pauline Blackie, Lillias Adlerchon, Bessie Wilkinson, George and Gerald of 'Photographics', Chelsea, and numerous librarians throughout the British Isles and Southern Ireland.

A special thank you to the following at Webb & Bower whose patience and hard work made the book possible: Delian Bower, Vic Giolitto, Rob Kendrew and Julia Frampton.

FAIRGROUND, THE SEAFRONT, WHITBY, YORKSHIRE